DRAWING IN BLACK & WHITE

DEBORAH
VELÁSQUEZ

DRAWING IN BLACK & WHITE

CREATIVE EXERCISES,
ART TECHNIQUES, AND
EXPLORATIONS IN **POSITIVE**
AND **NEGATIVE** DESIGN

QUARRY

Quarto is the authority on a wide range of topics.

Quarto educates, entertains and enriches the lives of our readers—enthusiasts and lovers of hands-on living.

www.QuartoKnows.com

First published in the United States of America in 2017 by
Quarry Books, an imprint of
Quarto Publishing Group USA Inc.
100 Cummings Center
Suite 406-L
Beverly, Massachusetts 01915-6101
Telephone: (978) 282-9590
Fax: (978) 283-2742
QuartoKnows.com
Visit our blogs at QuartoKnows.com

10 9 8 7 6 5 4 3 2 1

ISBN: 978-1-63159-280-5

Library of Congress Cataloging-in-Publication Data

Velasquez, Deborah, author.
Drawing in black & white : creative exercises, art techniques, and explorations in positive and negative design / Deborah Velasquez.
ISBN 9781631592805 (paperback)
1. Drawing–Technique.
NC730 .V45 2016
741.2–dc23

2016029239

Design: Burge Agency
Cover Image: Deborah Velásquez
Photography: Glenn Scott Photography
Illustration: Deborah Velásquez

Printed in China

Lionfish (p. 61) and Amalfi Coast (p. 101) for Minted®. Minted is a registered trademark of Minted, LLC.

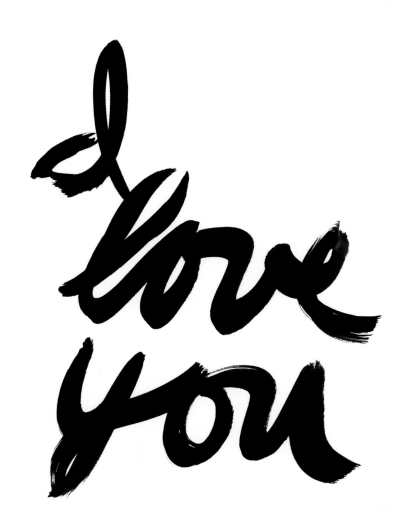

I DEDICATE THIS BOOK TO
MY BEAUTIFUL MOM, WHOSE
DETERMINATION, STRENGTH,
AND COURAGE MADE SO MUCH
POSSIBLE. SHE ALWAYS SAID,
"LIVE LIFE WITHOUT REGRET AND
DO EVERYTHING!"

ALSO FOR JOHN, ELÁN, AND
AUGUSTE, WITH LOVE.

CONTENTS

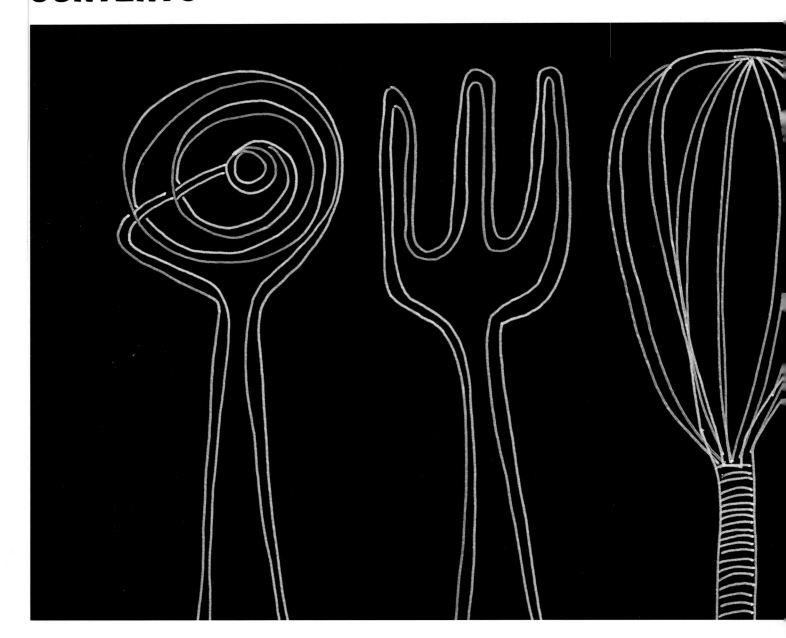

INTRODUCTION

Drawing in Black & White is about exploring simple drawing and creative play while using a limited palette. We will keep it simple and fun. With a few art supplies and basic creative exercises, you can create beauty. The projects explore line, shape, wash, stamping, and cut paper and their playful relationships with each other in positive and negative space. You will see how the integration of simple design principles, such as repetition, balance, space, and rhythm, give rise to beautiful, lively patterns. Your confidence and skill will build with each pen mark and with each exercise. *Drawing in Black & White* is simply presented, visually inspiring, and easy to follow. You will also find sixteen colored papers in the back of the book to use in your experimentation.

My love affair with pens and paper began in childhood. I was drawing every chance I got. I have always wanted to be an artist. Even today, I always carry a sketchbook and a handful of favorite pens with me wherever I go; I might see something I need to draw! This book was inspired by a personal challenge I undertook that I called "the black and white sketchbook project." I thought that if I kept things simple and didn't overthink them, that I could make art every day. Making art every day has been a personal commitment since I returned to a creative career after having my boys. I was determined to make art no matter how limited my time was with small children. Even if I only had an hour a day, I was going to make that hour count. I started with a stack of 5" x 7" (12.7 cm x 17.8 cm) tan craft cardstock cards and a pen. Hence the "keeping things simple" mantra.

I had a design teacher in art school who said, "If it doesn't work in black and white, color isn't going to fix it." I believe this to be true, and that is why I love sharing my inspiration and process with you. My hope is that you have fun, make art in its simplest form, and see how an easy warm-up exercise may just end up being a favorite framed art piece.

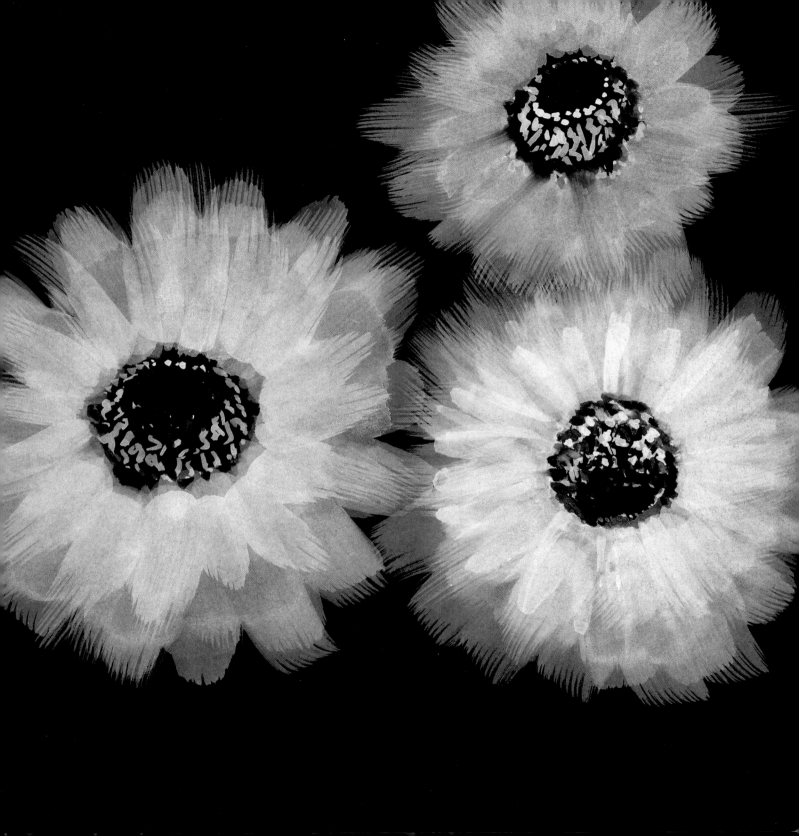

WHY WORK IN BLACK AND WHITE?

As you begin to draw and experiment with shape and line using just black and white, the contrast and the simplicity will be instantly evident. Black and white makes for a comfortable, low-noise creative palette. It allows your creative message to be quickly communicated. The results are clean and classic.

A limited palette lends itself to beautiful, strong, and sophisticated artwork. Dark backgrounds in black or gray with white paint make a bold statement. White pen or paint on a tan craft background has a modern yet rustic vibe.

It is restful to the creative eye to peel back color and create with less. This process returns the focus to basic yet important design principles and expands your creative process.

HOW TO USE THIS BOOK

When creating art, everything is possible with just paper and pen. There's no need to practice or sketch first. Just jump in and start creating. You will find sixteen drawing pages in the back of the book in gray, black, and tan to start your journey.

Try a few simple exercises. With a couple of supplies, you have all you need to challenge yourself creatively. Use the papers included to begin exploring your mark making, your line's personality, your hand, and your style. The key is to maintain a relaxed approach and do not feel like the materials are too precious to use. Draw and paint freely. Let accidents happen, such as paint drips, scribbles, and unintended lines—these may turn out to be your best work! I call it designing by accident.

In the beginning, you may want to replicate the designs you see on the page, but as you gain more experience and confidence, complete the exercises in your own style, with your own shapes, and with your own marks. That will be when the magic starts.

Use this book as a foundation, a place to grow your ideas and make your messes, mistakes, and masterpieces with confidence. Enjoy the process and be surprised by the art and beauty you create.

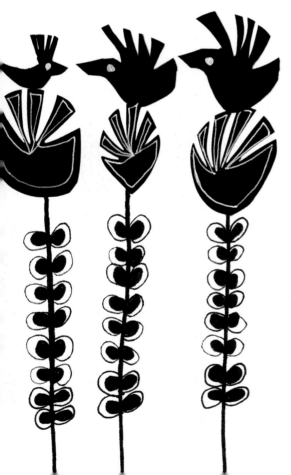

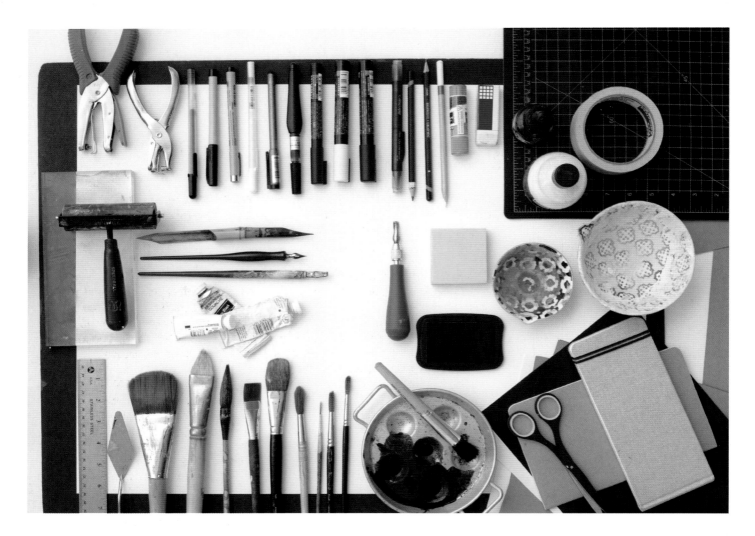

MATERIALS

Your first task as you dive into this book is to get familiar with your materials. Set out all of your supplies and try each pen, each brush, and each paper type. Get ready to have your materials teach you. Practice making marks and scribbles with each pen. Do the same on different papers. Then repeat this exercise using a couple of different brushes and watercolor or gouache. Notice how the tools move with the papers. Notice how heavy or light the marks are. For example, I learned that it is easier to draw a straight line by pushing away from you with your pen or brush. I also learned that it is easier to make a circle with a nice edge by pulling your pen or brush toward you.

WHAT SHOULD I DRAW ON?

Papers are made from the fibers of either wood pulp or cotton. Lower quality papers are made from wood pulp. Higher quality papers are made from cotton fibers that are more resistant to chemical breakdown over time. These papers are commonly referred to as "rag" paper. Many medium-grade papers are a combination of both.

Many of the projects in this book can be executed with multiple types of paper. If you just want to get started and only have printer paper on hand, that is perfectly suitable. Ideally, get some cardstock and some medium- and heavier-weight papers for drawing, and particularly when you get to the exercises that use paint. You will notice that different surfaces affect the type of marks you get. Your artwork deserves a good foundation, and you may enjoy the process more when you use nicer papers.

PRINTER PAPER or regular weight is great as scrap and for testing prints, line work, and drawing.

DRAWING PAPER, often part wood and part paper pulp, is a bit heavier than printer paper. It is available in white, black, and other neutrals, such as tans, browns, and grays.

CARDSTOCK (also called cover stock) is thicker and more durable than printer paper. Cardstock is easy to cut and work with and has a nice smooth surface for drawing.

SCRAPBOOKING PAPER offers smooth and textured surfaces for drawing and comes in weights suitable for stamping and water media.

BROWN CRAFT PAPER is a nice complement to black-and-white line or paint work and offers a rustic beauty.

Save **SCRAP PAPER, DISCARDED BITS FROM PROJECTS, AND PAPER BAGS.** Use them to test paint or line strokes, and to remove excess paint from brushes before stenciling. Always use scrap paper to get the flow going in your drawing implement as well as in your drawing hand, and warm up with a few scribbles and doodles before you start on your exercise.

ARCHIVAL PAPER is the highest quality acid-free paper and best for artwork that you want to last a long time.

WATERCOLOR PAPER is absorbent and is best for wet media. It is available in different weights and in three finishes, typically labeled as "rough," "cold press," and "hot press." Most artists prefer the textured finish of rough or cold press for transparent watercolors, because the texture helps control the paint. The smoother finish of hot press paper is desirable for opaque watercolors, for more detailed paint work, and for printmaking and drawing.

BRISTOL BOARD OR BRISTOL PAPER is a quality, heavier-weight paper, similar to cardstock and smooth for stamping and line work. It is typically acid free and is available in white, black, and various colors.

MIXED-MEDIA PAPERS AND BOARDS are ordinary papers that have been coated or primed, so they can accept almost any medium. They are suitable for water-based paints, inks, gouache, and more.

DECIDING WHAT IS RIGHT FOR YOU
Try different papers and see what feels best to you. I enjoy the smoothness of cardstock for line work and flat, even, ink stamp impressions. I like the sturdiness and absorbent nature of the heavier stock or watercolor paper for painting. Mixed-media paper and Bristol board/paper serve both purposes. Cardstock is great for collage making, cutting, and gluing.

Lighter-weight papers work well for sketching in pencil, pen, and marker, as well as for stamping. I like how cardstock feels in my hand, and I like that I can draw and paint on it without worrying about cost.

PAINTS AND INKS

INDIA INK is simple black-colored ink used for drawing with Sumi brushes or with calligraphy pens.

ACRYLIC INK is water resistant, dries quickly, and flows easily. It can be used for stamping as well. It has a translucent shine when dry.

BLOCK PRINTING INK is a rich, quick-drying, water-based ink used for rubber and linoleum block printing.

PIGMENT INK PADS are used for stamping carved block designs onto paper. They have a rich and vivid ink that dries on top of the paper, as opposed to soaking through, but takes longer to dry than dye-based inks.

GOUACHE is opaque watercolor paint with a velvety finish. It has a creamy yogurt consistency when mixed and is not waterproof. I have worked with this medium my whole creative career and it is, by far, my favorite. It is forgiving and versatile, and it dries fast as well. Dried gouache on your palette can be revived with a drop of water, so there is no waste! Darker colors get lighter when dry, and lighter colors dry darker. One note: Gouache can crack when dry, so do not fold or roll artwork made with this medium; store it flat.

PENS, PENCILS, AND BRUSHES

CALLIGRAPHY PENS can be fitted with various nibs that offer a variety of line weights. They are a great vehicle for mark making. I love my vintage calligraphy pen; I feel it has some history.

WATERPROOF MICRO-PIGMENT PENS are archival waterproof marking pens. They are great for drawing, don't bleed, and can be found in a variety of tip sizes.

PERMANENT MARKING PENS are waterproof but can occasionally bleed a little and are found in a variety of tip sizes.

PAINT PENS are opaque and water-based ink markers that dry to a matte finish.

GEL PENS are smooth-rolling ink pens for detail work.

BRUSH PENS create a brush-like, watercolor effect by a controlled flow from the well to the nib and can be used with ink and paint. They are easy to handle and transportable.

PENCILS are available in both soft and hard leads for drawing and shading.

BRUSHES come in a variety of sizes and shapes. We will be using a round, a pointed round, a flat, and a mop brush for our exercises. I like to use sable brushes. Always use an inexpensive brush for mixing paint.

SUMI BRUSHES are used for Chinese calligraphy and drawing and can be used with ink or gouache. Working with a Sumi brush is magical to me. I love to move the paint with expressive brushstrokes on paper to create written beauty. The magic lies in the parts of the brush tip, which allow thick to thin lines in the same fluid stroke.

ART BRUSHES are used to clear working surfaces of eraser residue and to brush off cut strips and residue from rubber blocks after carving.

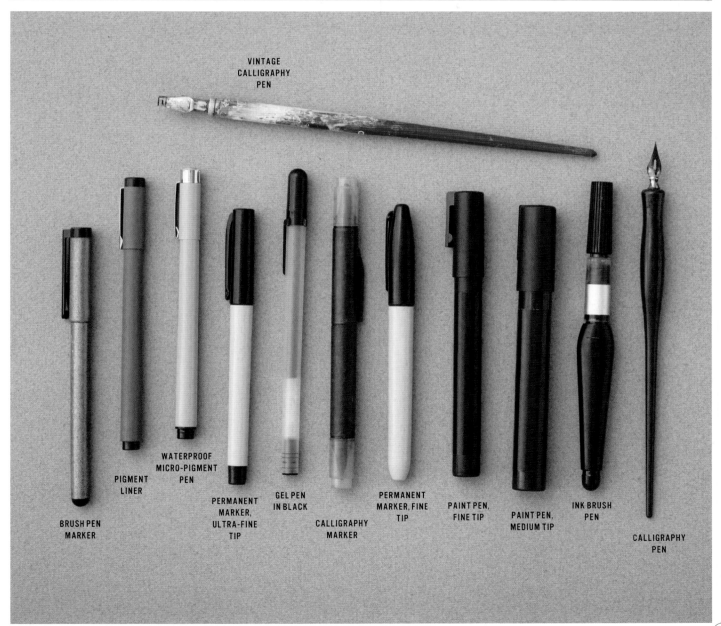

VINTAGE
CALLIGRAPHY
PEN

BRUSH PEN
MARKER

PIGMENT
LINER

WATERPROOF
MICRO-PIGMENT
PEN

PERMANENT
MARKER,
ULTRA-FINE
TIP

GEL PEN
IN BLACK

CALLIGRAPHY
MARKER

PERMANENT
MARKER, FINE
TIP

PAINT PEN,
FINE TIP

PAINT PEN,
MEDIUM TIP

INK BRUSH
PEN

CALLIGRAPHY
PEN

BLOCK PRINTING TOOLS

RUBBER CARVING BLOCKS come in white, gray, or pink rubber, much like eraser material. They are soft and offer a smoother cut when working with your tools. I prefer the thick, white blocks, which are easier to handle and less prone to tearing.

LINOLEUM BLOCKS provide a harder surface and are better for detail work.

A **LINOLEUM CUTTER WITH INTERCHANGEABLE TIPS** cuts rubber or linoleum blocks for printing. Tips 1 and 2 are for thin lines, tips 3 and 4 are for medium lines, and tip 5 is for cutting away large pieces. Cutting tools with wooden handles can be found with tips attached individually.

BRAYERS come in rubber or foam and are used for rolling paint onto carved blocks, for stenciling, and for mixing paint. I use the rubber type to warm paint by rolling it onto plexiglass for stenciling and block-printing exercises.

PLEXIGLASS makes a nice flat palette for painting and is a perfect top plate for distributing even pressure onto carved blocks for uniform impressions when printing.

A **BONE FOLDER** is used to rub on the wrong side of a drawing to transfer the image to a block. A wooden spoon also works for this.

SOFT LEAD PENCILS are for drawing on rubber blocks or transferring lines of artwork onto tracing paper, essentially making your own carbon transfer sheet.

TRACING PAPER is used for drawing and transferring line work from your design onto your rubber block. Remember that the image that is cut *into* the rubber block will print in reverse. Carbon paper may be used as well.

OTHER SUPPLIES

PALETTES provide a surface to mix and hold paint as you create. They come in a variety of sizes and designs, from metal to acrylic, so find a few to suit your needs. Some paints need convex wells for mixing, so small ceramic bowls are great for this, or invest in a metal or plastic palette with convex wells. Use old plates, sushi soy sauce holders, or small ceramic bowls with ridges to lay your brushes on as I do.

ARTIST TAPE has a secure hold but is repositionable and easy to remove without harming your artwork.

SCISSORS are used for cutting tasks.

A **CRAFT KNIFE** is great for cutting borders and shapes in a precise manner.

A **CUTTING MAT** protects your surface and is self-healing. The guidelines printed on the mat are a great help for cutting stencils and rubber blocks.

A **METAL RULER** doubles as a straightedge for cutting with a craft knife.

A **SEE-THROUGH PLASTIC RULER** is used for measuring and inking precise line work.

A **METAL PALETTE KNIFE** is helpful for mixing and scooping paint onto a palette. You can also use a plastic knife, a spoon, or a popsicle stick.

NEWSPAPER OR LARGE CRAFT PAPER is great for covering your inking and painting surfaces.

DECOUPAGE OR GEL MEDIUM is used as glue for collage work.

LINE WORK
Types of lines

VINTAGE CALLIGRAPHY PEN

CALLIGRAPHY PEN

PAINT PEN, MEDIUM TIP

PAINT PEN, FINE TIP

INK BRUSH PEN

BRUSH PEN MARKER

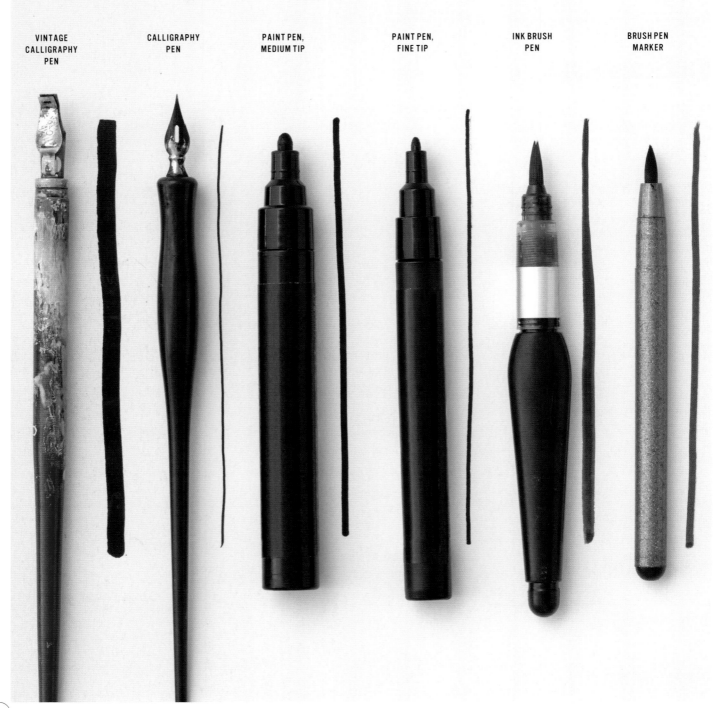

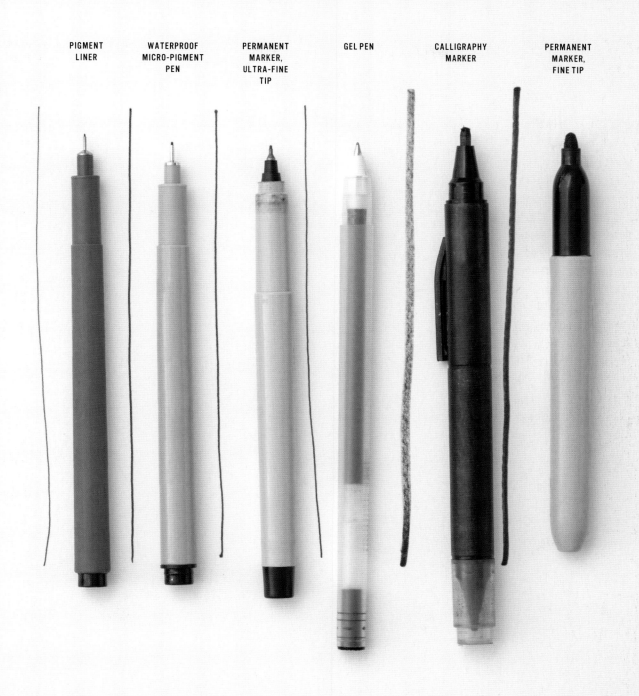

PIGMENT
LINER

WATERPROOF
MICRO-PIGMENT
PEN

PERMANENT
MARKER,
ULTRA-FINE
TIP

GEL PEN

CALLIGRAPHY
MARKER

PERMANENT
MARKER,
FINE TIP

Exercise 1:

WARM-UP

WARM UP YOUR DRAWING HAND WITH FREE-FORM LINES AND SHAPES TO GET YOUR CREATIVE JUICES FLOWING AS YOU PREPARE TO DIVE INTO OTHER PROJECTS. I USE A TIMER TO TIME MY EXERCISES. USING ONE FREES YOU FROM OVERTHINKING OR OVERSTUDYING YOUR SUBJECT. UNDER A TIME CONSTRAINT, YOU WILL FOCUS ON WHAT IS MOST IMPORTANT IN YOUR VISUAL REPRESENTATION. I SUGGEST ONE MINUTE TO START. BE BRAVE AND TRY THIRTY SECONDS! MAKE IT A MORNING ROUTINE. MY YOUNGEST CHILD LOVES THIS EXERCISE; IT IS AN EASY, TIDY WAY TO MAKE ART WITH YOUR LITTLE ONE.

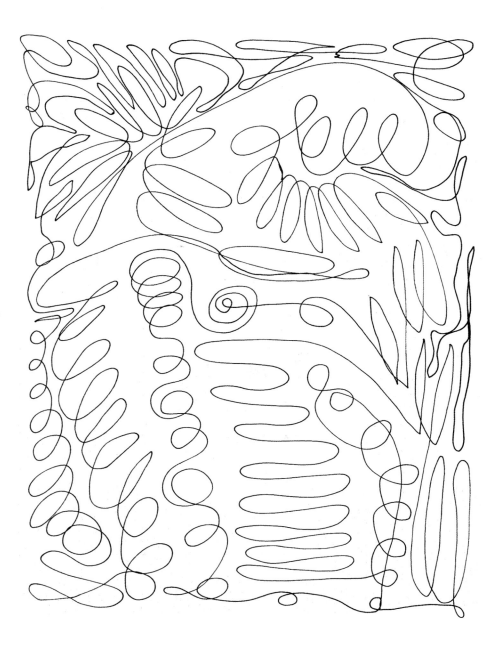

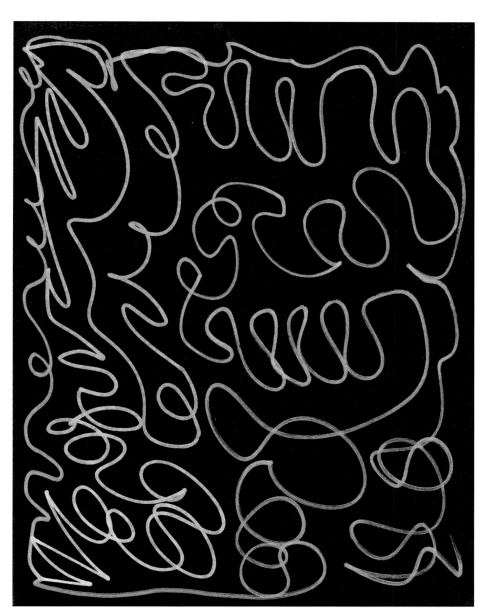

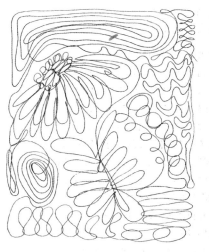

1. Play some music.

2. Set up your sketch paper.

3. Put the tip of your pen or pencil on the paper and, without lifting it, cover the entire page with lines, circles, squiggles, or angles.

4. Get the flow going in your drawing hand. Stand up and put your body into it.

5. Let your lines be free, loose, overlapping, and fun.

Exercise 2:

GESTURE DRAWING

IN THIS EXERCISE, YOU WILL DRAW WITH ABANDON AND CAPTURE THE ESSENCE OF YOUR SUBJECT QUICKLY. GESTURE DRAWING HAS ALWAYS BEEN ASSOCIATED WITH FIGURE DRAWING, BUT I LIKE TO APPLY IT TO OBJECTS OR ARCHITECTURE, TOO. THERE IS NO OPPORTUNITY FOR OVERTHINKING IN THIS EXERCISE. IT IS SO FREEING, AND I LOVE THAT SKETCHY FEEL THAT HAS PASSION, EMOTION, AND MOVEMENT IN IT.

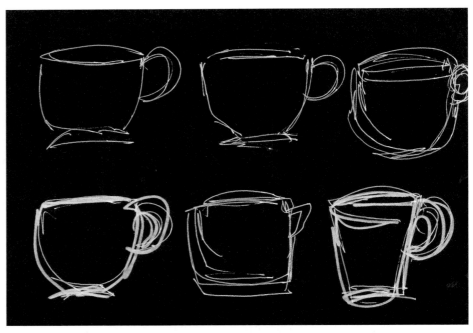

MATERIALS

Timer (optional)

Drawing instrument
of choice

Sketch paper,
printer paper, or
a paper bag

Craft paper or
cardstock

1. I prefer to stand with my drawing pad propped up at an angle: It makes for a looser hand while drawing gesturally. Set up your drawing materials and reference objects in a way that is comfortable for you.

2. Set a timer for 20 to 60 seconds per object (this is optional). Study your object quickly and draw quickly. As your eye follows the shape, your drawing hand captures the essence of what you see. The drawing should not be perfect or realistic. Make your marks intentional and decisive.

3. Using five to ten sheets of inexpensive sketch paper, draw individual sketches of your object.

4. When you are finished with your individual sketches, draw five to ten of your favorites on one sheet of craft paper or cardstock to create a final piece of art.

5. Your drawing will have personality in its lines and curves. You can see this as you start and stop and as you move quickly up, down, and around the page. Think of your gesture drawing as a short story rather than a novel.

Exercise 3:

TWO-HANDED REFLECTION DRAWING

IN THIS EXERCISE, YOU WILL DRAW IN A
FREE-FORM MANNER USING BOTH HANDS
SIMULTANEOUSLY ON A SHEET OF PAPER. IT
MIGHT FEEL AWKWARD AT FIRST, BUT BE LOOSE
AND HAVE FUN WITH IT. YOU'LL BE SURPRISED
BY WHAT YOUR NON-DOMINANT HAND CAN DO
WHEN YOU DON'T OVERTHINK IT.

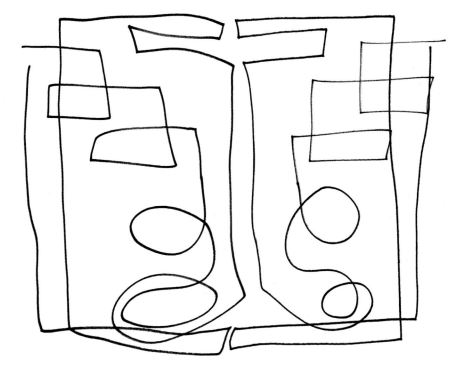

1. It is best to stand over your work space for this exercise. Tape the paper onto your work surface so it won't move.

2. Take a marker or pencil in each hand and place them on the paper. Start anywhere on the page.

3. Without lifting your markers, move both hands at the same time in opposite directions to draw free-form shapes in a mirror image.

4. Fill the page with lines, circles, squiggles, or whatever you want.

MATERIALS

Music

White sketch paper

Pen or pencil

Exercise 4:

FOLLOW THE LINE

IN THIS EXERCISE, YOU CREATE A PIECE WITH VISUAL RHYTHM AND FLOW. THE LINES ARE ALWAYS DRAWN IN PARALLEL. THIS IS A GREAT MEDITATIVE EXERCISE THAT PUTS YOU "IN THE ZONE."

1. Play some music.

2. Set up your sketch paper. If you want, you can start and stop new drawings.

3. Put your pen or pencil on the paper and draw a curving line. Start and stop where you wish.

4. Draw another line parallel to the first, following the direction of the line, and then draw another parallel to that one.

5. Go in any direction—the key is not to cross lines or overlap them. Fill the page.

6. Try this exercise in paint. See if you can apply the same discipline. (See A.)

A

MATERIALS

Black, gray, or tan lightweight or heavy cardstock

White gel pen, black gel pen, or permanent marker

Exercise 5:

CONTOUR DRAWING WITH A CONTINUOUS LINE

IN THIS EXERCISE, DRAW YOUR SUBJECT, WHICH CAN BE A STREET SCENE, NATURE, A CHAIR FROM YOUR LIVING ROOM, OR EVEN SOMETHING FROM YOUR IMAGINATION, IN ONE CONTINUOUS LINE. I USED A STREET IN AMSTERDAM AND TREES FROM AN IMAGINARY FOREST IN MY EXAMPLES.

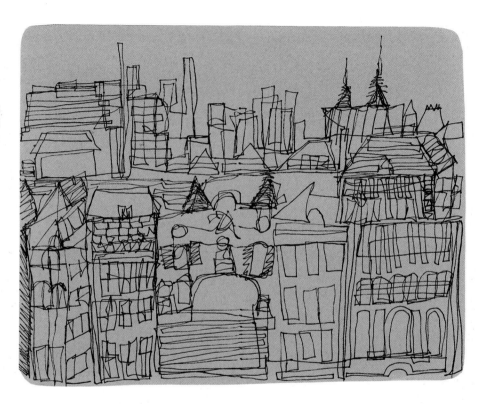

1. Find reference materials from your home surroundings, pictures from magazines, or online.

2. Set up your drawing materials.

3. Draw what you see without lifting your pen. You can overlap lines, draw in details, and make marks all while keeping your lines connected. Your hand will find a natural rhythm as you glide across the page.

Exercise 6:

BLIND CONTOUR DRAWING

IN THIS EXERCISE, YOUR PEN NEVER LEAVES THE PAPER AND YOUR EYES STAY FIXED ON YOUR SUBJECT, WHICH CAN BE A STILL LIFE FROM YOUR DESK, A PERSON'S FACE, OR ARCHITECTURE, LIKE IN MY EXAMPLE. THIS METHOD REALLY HELPS YOU "SEE" YOUR SUBJECT IN A FOCUSED WAY.

1. Select your reference materials from your work area, travel books, or online.

2. Set up your drawing materials.

3. Study your reference for a minute to get comfortable with what you see. Put your pen on the paper without looking down. For about one minute, draw what you see without lifting your pen or looking down. I use a timer to keep track. You will be amazed at how long a minute is!

MATERIALS

Black, gray, or tan lightweight or heavy cardstock

White gel pen, black gel pen, or permanent marker

Timer (optional)

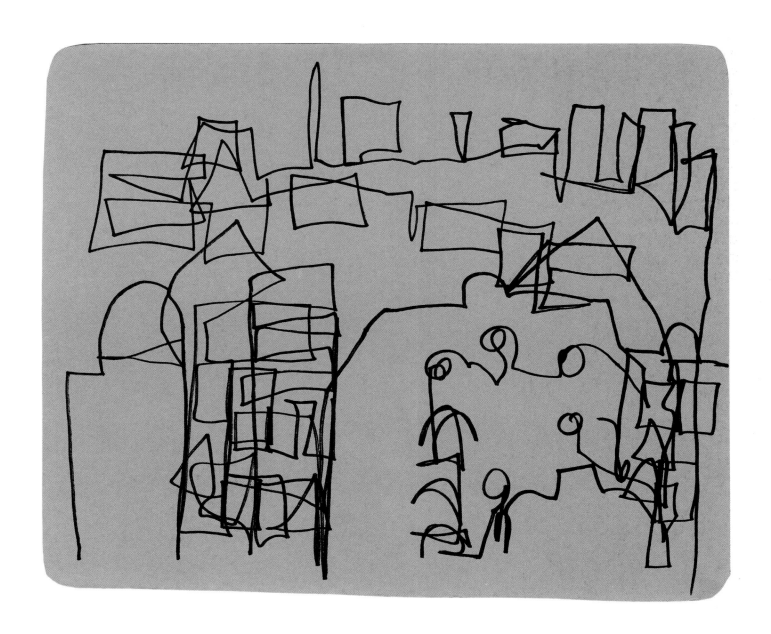

MATERIALS

Black craft paper in heavy cardstock

White gel pen

Exercise 7:

CONTINUOUS LINE KITCHEN DRAWINGS

YOUR KITCHEN IS FULL OF FUN SKETCHING IDEAS—CERAMICS, GLASSWARE, UTENSILS. CHOOSE SOME INTERESTINGLY SHAPED ITEMS FOR THIS EXERCISE, SUCH AS A STACK OF BOWLS, A SINUOUS VASE, OR A SET OF UTENSILS, AS SHOWN HERE. EACH ITEM IS SKETCHED WITH A CONTINUOUS LINE, WHICH GIVES THE DRAWING ITS CHARACTERISTIC LOOK.

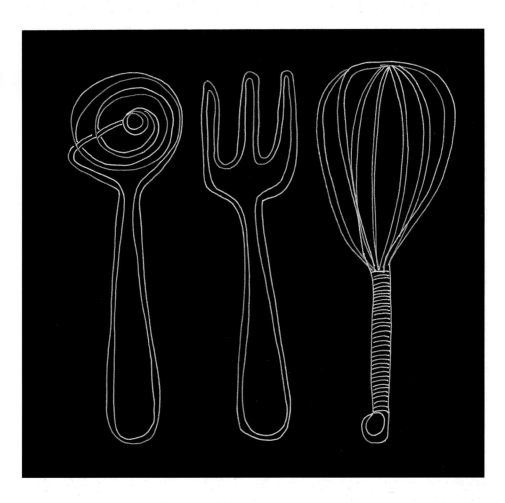

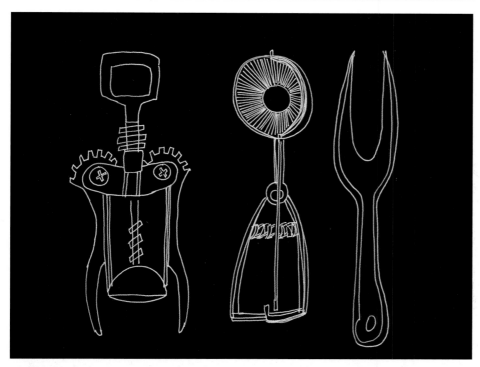

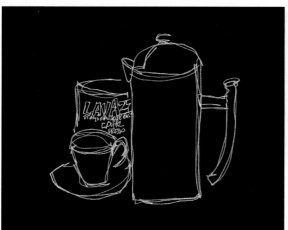

1. Find and arrange your reference materials from your kitchen, or use pictures from cookbooks or online.

2. Set up your drawing materials.

3. Jump in without sketching first. Your lines should be free and loose. To make a continuous line drawing, put your pen on the paper and draw what you see without lifting your pen, periodically looking at your reference.

MATERIALS

Black, gray, or tan
craft paper or heavy
cardstock

White gel pen,
black gel pen, or
permanent marker

Exercise 8:

LINE WORK BOTANICAL DRAWINGS

THIS EXERCISE FOCUSES ON USING LINE WORK
AND DETAILS TO DRAW ITEMS FROM NATURE.
THE EXAMPLES SHOWN ARE FLOWER AND LEAF
STUDIES.

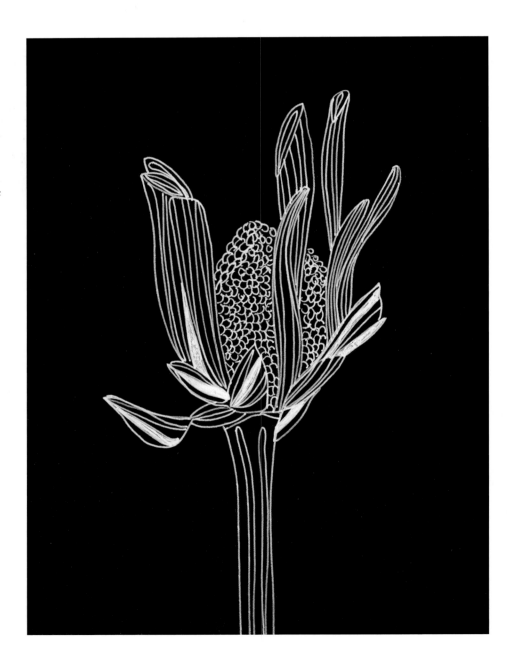

1. Select your reference materials, such as flowers from the garden, pictures from flower books, or images online.

2. Set up your drawing materials.

3. Draw straight onto the paper, no sketching first: Just dive right in and draw only in line. You can shade with line work if you like when filling open spaces on your flower or plant.

MATERIALS

Gray or tan lightweight or heavy cardstock

White gel pen

Exercise 9:

PLAYING WITH NEGATIVE SPACE

IN THIS EXERCISE, YOU WILL PLAY WITH LINE WORK AND NEGATIVE SPACE. JOINING NEGATIVE SPACES WITH MARKS CREATES INTERESTING PATTERNS. THE EXAMPLE SHOWN USES DIRECTIONAL LINES FROM LEFT TO RIGHT AND PARALLEL TO ONE ANOTHER. AS YOU FILL THE SPACES, YOUR DESIGN COMES TO LIFE ORGANICALLY.

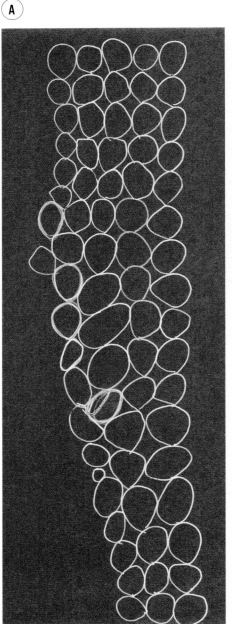

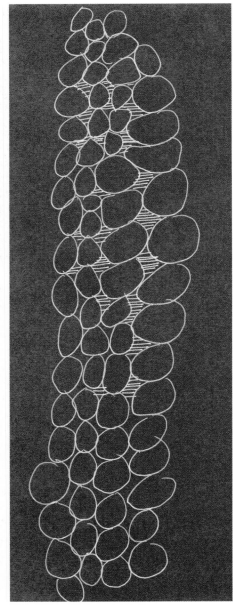

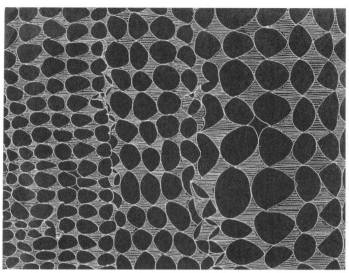

1. Set up your drawing materials.

2. In column formation, draw a vertical series of organic circles. Draw one touching the next, going from top to bottom. Draw quickly and without hesitation for better results. Vary the sizes for visual interest.

3. Make another column of organic circles, top to bottom again, until you have filled the page from left to right. Each circle should touch the one you just drew and the one in the adjacent column. These two touch points create negative space. (See A.)

4. With your gel pen, make directional lines to fill the negative spaces between the circles. This makes for a meditative exercise with beautiful results. (See B.)

5. As you fill the page with white lines, you create a web-like pattern with movement and form.

The image above is another example of playing with line work and negative space. Here, most of the circles are filled with directional lines and the negative spaces between the circles are left blank.

Exercise 10:

MARK MAKING FOR TEXTURE, VALUE, AND FORM

WE ALL HAVE OUR DOODLING STYLES, AND MARK MAKING IS NOT VERY DIFFERENT. IN THIS EXERCISE, YOU WILL MAKE MARKS TO PLAY WITH TEXTURE, VALUE, AND FORM.

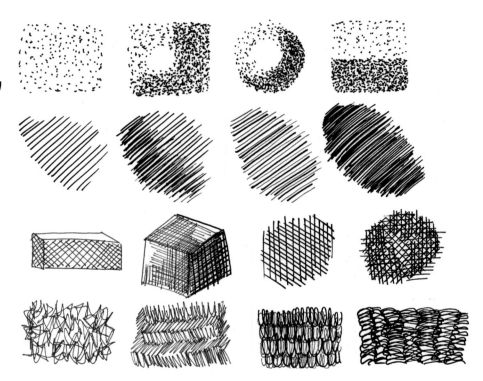

1. Choose a pencil, gel pen, or paint pen. On your paper, you will create a grid of four rows and four columns. Label the rows "stippling (dots)," "directional lines," "crosshatching," and "texture patterns."

2. Make your marks with a variety of implements and materials, working from left to right, with the left being the lightest mark and the right the darkest one. You will have four samples for each technique. Your personality will show in your marks.

I have my "go to" marks, and I keep a file of the ones I like to use in detail work for shading. Some of my favorites can be seen in these examples.

MATERIALS

Black, gray, or tan lightweight or heavy cardstock

Pencil

White gel pen, black gel pen, or permanent marker

Paint pen

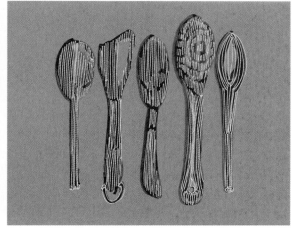

TIP: You can also make marks in paint. Before properly cleaning your brushes, make marks on scrap pieces of paper to keep for reference in a mark-making file. It's a great way to use up excess paint on your brush.

TIP: Make marks with toothpicks, an old comb, tweezers, paintbrushes with cut tips, twigs from the garden. Anything can be a mark-making tool!

Exercise 11:

CREATE TEXTURE WITH WRINKLED AND FOLDED PAPER

IN THIS EXERCISE, YOU CREATE TEXTURED AND ABSTRACT ART BY FOLDING, WRINKLING, OR CRUMPLING PAPER, AND THEN APPLYING A WASH TO COVER THE SHEET. THESE CAN BECOME AN ART PIECE OR A GREAT ADDITION TO YOUR COLLAGE OR DIGITAL LIBRARY FOR LATER USE. CONSIDER THIS TO BE MARK MAKING ON A LARGER SCALE.

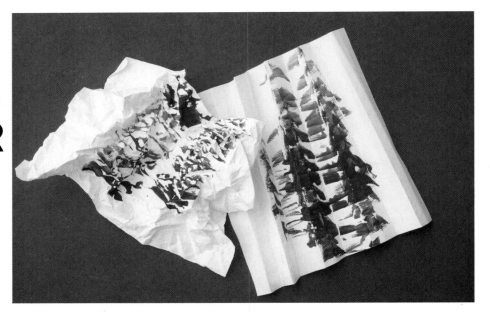

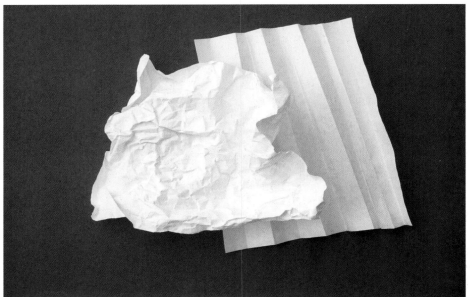

(A)

Newspaper or large craft paper

Black, gray, or tan medium-weight craft paper (thin enough to fold or crumple)

Palette

Black or white gouache, depending on the color paper you choose

Inexpensive brush for mixing

Mop brush or flat brush to make wash strokes

Black or white paint pen, marker, or gel pen

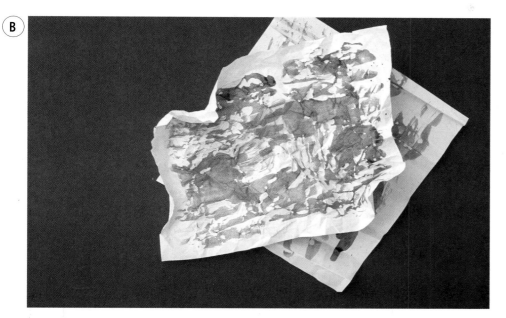

B

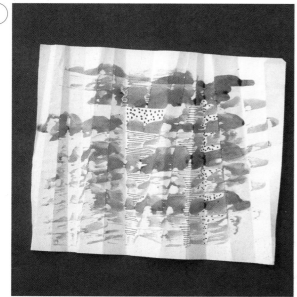

C

1. Cover your painting space with newspaper or large craft paper.

2. Wrinkle, fold, and crumple your paper. (See A.)

3. Open up your paper and lay it flat. Lightly smooth it down a bit with your hand.

4. On a palette, mix the gouache with water to get a smooth, yogurt-like consistency. Use an inexpensive brush for mixing. Using a mop or flat brush, paint the gouache with broad strokes over the entire sheet. The paint will catch the lines made by the folds yet leave valleys of white space. (See B.)

5. Study your creation and decide which marks to make in the valleys of negative space. Draw directional lines, stippling (dots), crosshatching, or texture patterns in pen. (See C.) You may choose to leave it as is, creating a fun piece of abstract art.

Exercise 12:

CONNECT THE DOTS

THIS DRAWING STARTS WITH RANDOM DOTS ON THE PAGE THAT ARE THEN CONNECTED WITH LINE WORK IN PEN OR GOUACHE TO CREATE A DESIGN. EXPERIMENT WITH CONNECTING OTHER SHAPES, SUCH AS TRIANGLES, SQUARES, OR RECTANGLES, FOR A FUN VARIATION.

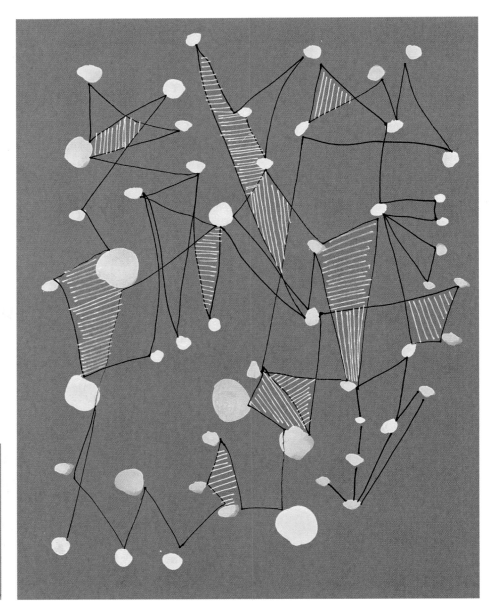

1. Cover your painting space with newspaper or large craft paper.

2. On a palette, mix the gouache with water to get a smooth, yogurt-like consistency. Use an inexpensive brush to mix the paint.

3. Load your paintbrush with paint and apply dots randomly on your paper. Paint dots of different sizes, varying the spacing. (See A.)

4. Connect the dots with the fine black marker. Move the pen from dot to dot all over the page. Move freely on the page and trust the flow and rhythm of your hand movements. (See B.)

5. When all the dots are connected, you can fill the shapes made by the intersecting lines using an ultra-thin brush or a gel pen.

6. The sample shown uses directional lines to fill shapes. Fill as many shapes as you like to complete your design.

7. See variations of designs and mark-making ideas in the images at right.

A

B

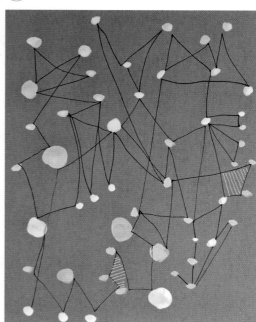

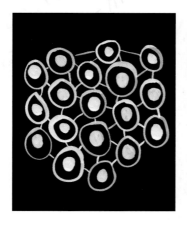

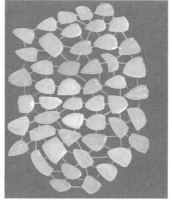

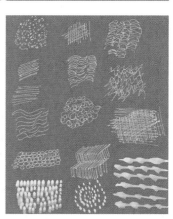

MATERIALS

Newspaper or large craft paper

White paint pen in a variety of tip sizes

Black or tan craft paper or heavy cardstock

Exercise 13:

SCRIBBLE AND FILL

EXPRESSIVE LINES INTERSECT TO CREATE NEGATIVE SPACE. THEN THE NEGATIVE SPACE IS FILLED WITH SIMPLE OR DECORATIVE MARKS. THIS EXERCISE MAY ALSO BE DONE WITH A BRUSH AND PAINT FOR A DIFFERENT LOOK.

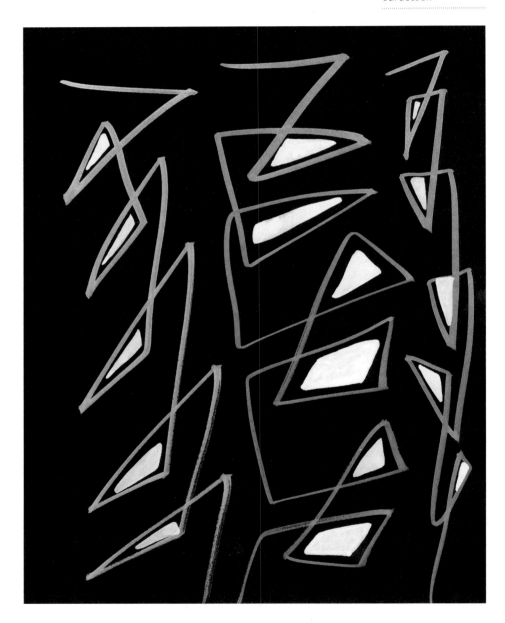

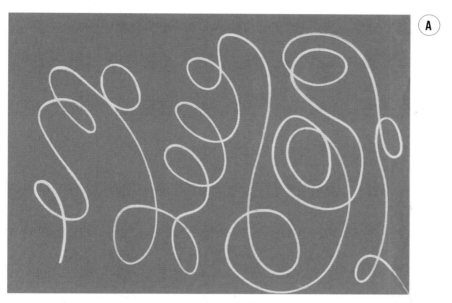

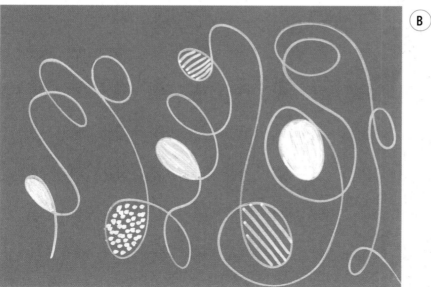

1. Cover your painting space with newspaper or large craft paper.

2. With your paint pen, draw straight onto the craft paper or cardstock in a free-flowing manner. Keep your pen on the paper until you have filled up the page. It is best to stand while doing this part of the exercise. Put your body into the drawing as your pen moves freely around the paper, crossing lines and circles you've already drawn. (See A.)

3. When you are done with your free-form scribble, fill the shapes made by the intersecting lines with marks. The sample shown uses directional lines and solid coloring to fill shapes. (See B.)

MATERIALS

Newspaper or large craft paper	Pointed round brush
White or black gouache	Black, gray, or tan heavy cardstock or watercolor paper
Palette	Mop brush
Inexpensive brush for mixing	Round brush
	Flat brush

Exercise 14:

BRUSH DISCOVERY

IN THIS EXERCISE, YOU WILL EXPLORE YOUR BRUSHES, THE MARKS THEY CAN MAKE, AND THE BEAUTY YOU CAN CREATE. I WILL SHOW FOUR BASIC BRUSH TIPS AND THE MARK EACH MAKES. I OWN MORE THAN 150 BRUSHES, BUT I ALWAYS GO TO MY FAVORITE SIX FOR PAINTING. I HEAR THIS A LOT FROM FELLOW ARTISTS TOO.

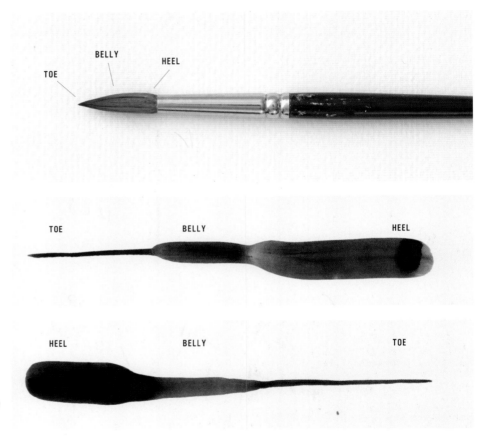

TIP: Your hand can control the effect of the paint depending on how you hold your brush. This is true no matter what the brush tip might be.

1. Cover your work space with newspaper or large craft paper.

2. Put a few generous dots of gouache onto your palette and add water slowly. Mix the gouache to a creamy, yogurt-like consistency. Use an inexpensive brush to mix the paint.

3. Use a pointed round brush for the start of the exercise. Load the brush with paint and hold it perpendicular to the cardstock or watercolor paper—at a 90-degree angle—and paint a few strokes.

TIP: For florals, study the petals and then play with brush pressure to mimic the shapes.

4. Then try holding the brush like a pencil, at a 45-degree angle, and paint some strokes. Use all the parts of the brush—the toe, the belly, and the heel. Go lightly on the heel so you

don't damage the bristles. You will see line weights change as the pressure from your hand changes. Each artist has his or her own line personality.

5. Make fine, medium, and thick lines. Pull the brush left to right across the paper and make linear rows from the top to the bottom of the page. You will get a sense of how long your loaded

brush paints until you have to reload it with paint. Get a feel for the brush's capabilities. Repeat these steps using a mop brush, a round brush, and a flat brush.

| **POINTED BRUSH** | **MOP BRUSH** | **ROUND BRUSH** | **FLAT BRUSH** |

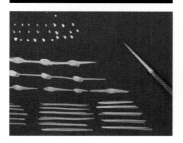 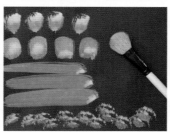 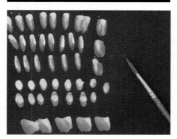 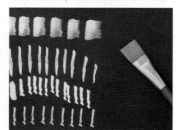

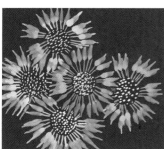 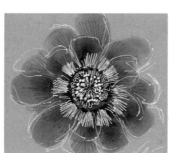 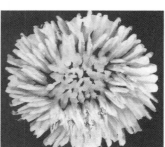 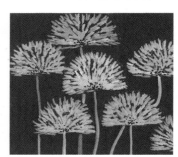

Paint with the side of your brush.

Place and lift your brush, leaving the mop shape wash on your paper.

Use a thick and thin technique for petal shapes. Working from thin to thick, push and pull your brush. Try this pattern with your brush: *toe, belly, toe, belly, toe, belly, toe.*

Paint with the toe of the brush.

MATERIALS

Newspaper or large craft paper

White gouache

Palette

Inexpensive brush for mixing

Black heavy cardstock or watercolor paper

Round paintbrush

Exercise 15:

PAINTING WITH GOUACHE

IN THIS EXERCISE, YOU WILL PAINT WITH GOUACHE TO CREATE AN ABSTRACT PIECE IN BLACK AND WHITE. I HAVE WORKED WITH GOUACHE MY WHOLE CREATIVE CAREER. TO SAY I LOVE IT IS AN UNDERSTATEMENT. IT IS THE MOST FORGIVING AND MOST VERSATILE MEDIUM. IT CAN BE REVIVED AFTER IT DRIES UP WITH JUST A FEW DROPS OF WATER. GOUACHE ALSO DRIES QUICKLY AND GIVES AN OPAQUE, MATTE LOOK.

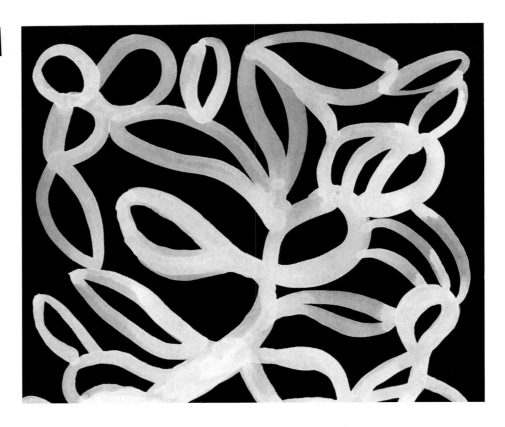

NOTE: There are three consistencies of gouache paint: heavy/creamy (almost the consistency of yogurt), medium, and light. These are achieved by the amount of water you mix with the gouache. The creamier consistency is a flat opaque color. The medium and light versions give more of a watercolor effect.

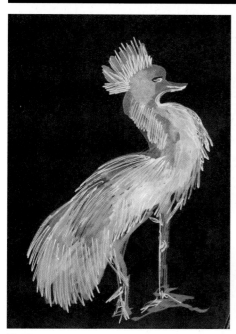

Light

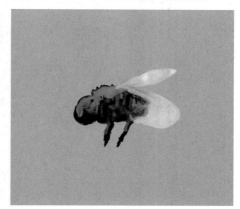

Medium

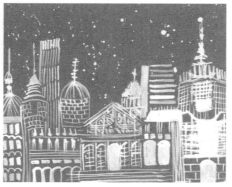

Heavy and creamy

1. Cover your work space with newspaper or large craft paper.

2. Put a few dots of gouache onto your palette and slowly add water. Mix the gouache to a creamy, yogurt-like consistency. Use an inexpensive brush to mix the paint.

3. Set up the black paper you will paint on.

4. Load the round brush with white gouache and softly paint leaf and loop shapes. Painting these shapes allows you to feel the flow and movement of the paint as you push and pull it across the paper. You will get a sense for how long your loaded brush paints before you have to reload.

5. Paint with the belly of the brush, which makes for a nice, thick line.

6. Fill your page, painting confidently right to the edges of your paper. I recommend you glide your strokes off the edges so there is no visual hesitation in your stroke.

Exercise 16:

WHITE ON WHITE

IN THIS EXERCISE, WE USE WHITE WASHES IN
GOUACHE TO CREATE A BASIC FORM, AND THEN
ADD DETAIL WORK WITH GEL PENS TO DEFINE
AND GIVE LIFE TO OUR SUBJECT.

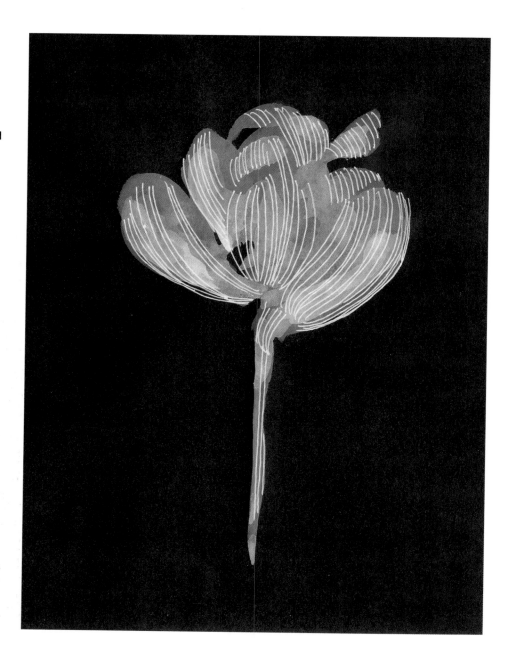

MATERIALS

Newspaper or large craft paper

Palette

White gouache

Inexpensive brush for mixing

Black heavy cardstock or watercolor paper

Mop brush

Round brush

White gel pen

1. Cover your work space with newspaper or large craft paper.

2. On a palette, mix the white gouache with water to a watercolor-like consistency. This creates a thinner body of paint. Use an inexpensive brush to mix the paint.

3. Set up the black paper you will paint on. Find a flower to use as your reference, either in nature or in a gardening book. Load the mop brush with white paint and softly paint the foundation petals of your flower. See A for a sample of a crocus. The round brush lets you lay a large area of color quickly. Let the paint dry.

4. Paint a second wash of color on only small parts of the existing flower as your highlight layer with your round brush. (See B.) This technique, called glazing, will give the flower form and a feeling of transparency. Let your artwork dry before doing any pen work.

5. With your white gel pen, create a detailed third layer. Make marks as you like. I like to follow the edge of the petal for definition. Fill in as many petal shapes as you like to complete your design. Vary your marks. Try lines, circles, crosshatches, dots, and more.

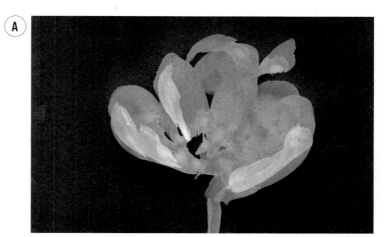

(A)

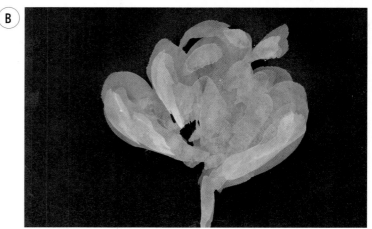

(B)

An example without line work

Exercise 17:

FLOCK
OF BIRDS

IN THIS EXERCISE, YOU WILL HAVE FUN WITH
ABSTRACT WASHES TO CREATE A BIRD FAMILY.
A CIRCULAR WASH—OR BLOB OF PAINT, IF
YOU WILL—CAN BE THE BEGINNING OF AN
IMAGINARY ANIMAL, PLANT, FLOWER, OR
PATTERN. USING A GEL PEN OR MARKER, WE
WILL ADD LEGS AND A BEAK TO OUR CIRCULAR
WASH TO BRING THE BIRD TO LIFE.

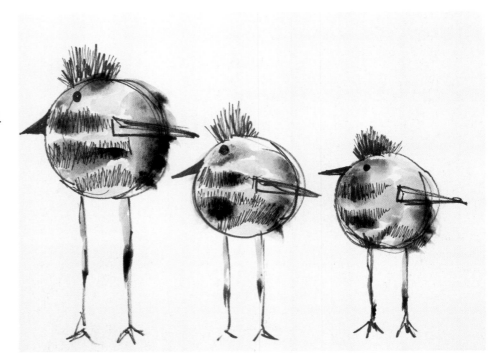

MATERIALS

Newspaper or large
craft paper

Palette

Black gouache or
black watercolor

Inexpensive brush
for mixing

White heavy
cardstock or
watercolor paper

Mop brush or
flat brush

Black paint pen,
marker, or gel pen

TIP: Hold a mop brush or flat brush upright and twirl the brush around 360 degrees to make an almost perfect circle.

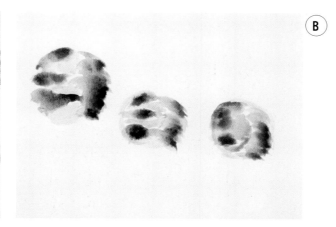

B

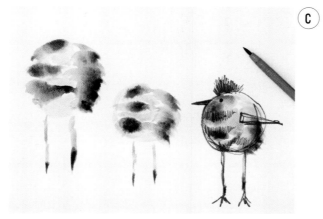

C

Arbitrary fun washes can become all sorts of animals or imaginary friends.

1. Cover your work space with newspaper or large craft paper.

2. On a palette, mix black gouache with water to get a watercolor-like consistency. This creates a thin body of paint. Use an inexpensive brush to mix the paint.

3. Set up a sheet of white paper, either cardstock or watercolor paper. Use this sheet to test painting your wash shapes.

4. Load the brush with black paint and softly paint circular washes. Fill your practice page. For feathery effects, rest your brush on the paper at the start of your circle and pull the paint a bit. Lift your brush, then rest it again; pull and then rest again. (See A.)

5. Set up the white paper you will paint your birds on. Paint three circular blobs or a free-form shape. Let your artwork dry before doing any pen work. (See B.)

6. With your black pen, create fun details for your bird family. Add beaks, wings, legs, and tufts of feathers for crowns to complete your design. Add more personality with lines, circles, crosshatches, dots, and so on. (See C.)

Exercise 18:

WASHES, SHADOW, AND TONE WITH PEN AND PAINT

IN THIS EXERCISE, WE WILL BUILD A STILL LIFE DRAWING OF FRUITS OR VEGETABLES BY LAYERING WHITE WASHES IN GOUACHE ON TOP OF EACH OTHER. THIS WILL CREATE SHADING, GIVING DEPTH AND FORM TO YOUR SUBJECT. SHADING, HIGHLIGHTS, AND LOWLIGHTS WILL ALSO BE ACHIEVED AS YOU ADD DETAIL USING BLACK AND WHITE PAINT PENS. ART CREATED WITH WHITE GOUACHE HAS A CALM AND QUIET BEAUTY.

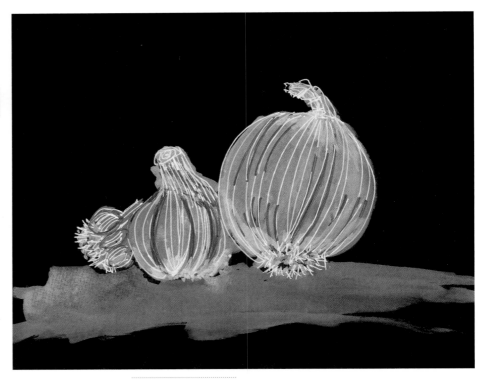

MATERIALS

Newspaper or large craft paper

Palette

White gouache

Inexpensive brush for mixing

Black heavy cardstock

Round or mop paintbrush

Black permanent marker

White and black gel pens

Examples of
gouache tonal work
with and without
detail line work

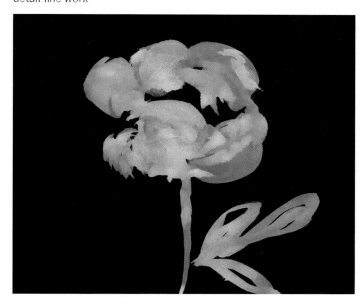

1. Cover your work space with newspaper or large craft paper.

2. Find a couple of vegetables or pieces of fruit to use as a reference. I have chosen an onion and bulbs of garlic.

3. Study the reference and notice your dark tones, medium tones, and highlight areas.

4. On a palette, mix the white gouache with varying amounts of water to get three levels of wash: dark (thickest), medium (in the middle), and light (thinnest). You will layer from the light transparent white to the medium wash to the opaque white. Use an inexpensive brush to mix the gouache.

5. Set up the paper you will paint on. Load a round or mop brush with the lightest level of white gouache.

TIP: Use a hair dryer to speed drying time.

TIP: To use a wet-on-wet technique, do not let the paint dry between layers and let the colors bleed into each other.

6. Paint the foundation of your vegetable still life with a light hand. (See A.) Let the paint dry to achieve a glazing technique or see the tip (right) for wet-on-wet.

7. Paint a second wash with the medium tone of gouache on the existing vegetable shapes. Find the medium tones in your reference so the wash is placed selectively. Let the paint dry. (See B.)

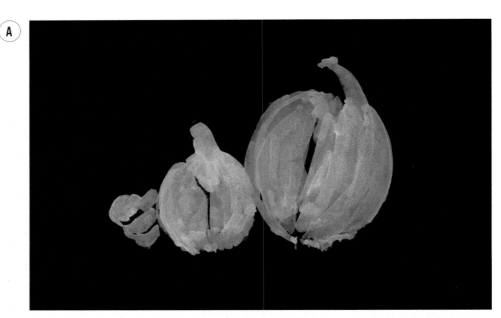

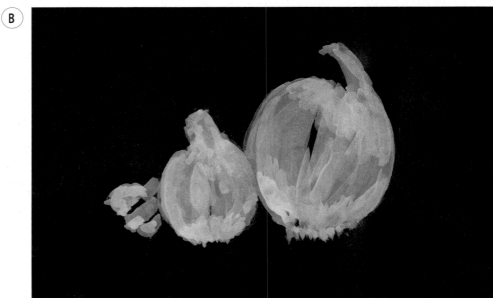

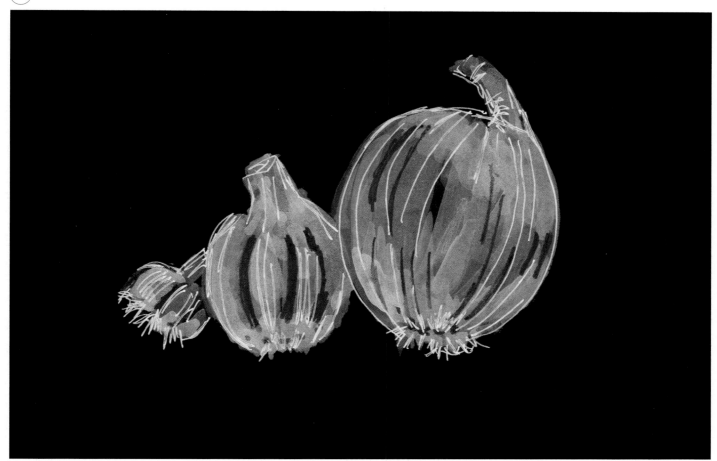

(C)

8. To finish your piece, paint a few dark areas and leave small parts of the underlayers of the vegetables as your highlights peeking through; this will give the vegetables form.

9. Let your artwork dry before doing any pen work.

10. With your marker and gel pens, create details. Use the white gel pen or more gouache paint for highlights, and use the black gel pen or marker for the darker areas. (See C.)

Exercise 19:

BLACK GOUACHE WASHES AND TONES WITH DETAIL WORK IN PENCIL AND PEN

HERE, YOU WILL CREATE A FLOWER WITH BLACK WASHES OF GOUACHE IN LIGHT, MEDIUM, AND DARK TONES, LAYERING FROM LIGHT TO DARK AS YOU WOULD WITH ANY WATERCOLOR. DETAIL WORK WILL BE DONE IN WHITE PAINT, PENCIL, AND WHITE AND BLACK GEL PENS TO GIVE YOUR FLOWER DEFINITION.

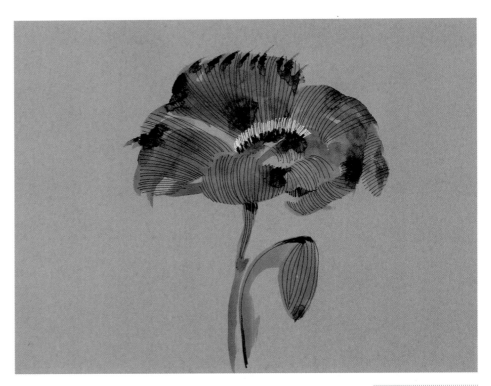

MATERIALS

Newspaper or large craft paper

Palette

Black gouache

Inexpensive brush for mixing

Gray heavy cardstock or watercolor paper

Round or mop paintbrush

White and black gel pens

Pencil

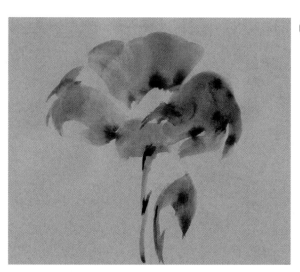

A

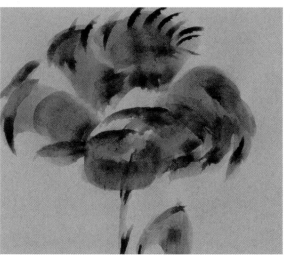

B

1. Cover your work space with newspaper or large craft paper.

2. Find a flower to use as your reference, either in nature or in a gardening book. Choose a flower with nice dark and medium tones, as well as highlight areas.

3. On a palette, mix the black gouache with varying amounts of water to get three levels of wash: dark (thickest), medium (in the middle), and light (thinnest). You will layer from the light transparent black to the medium to the opaque. Use an inexpensive brush to mix the paint.

4. Set up the gray paper you will paint on. Load a round or mop brush with the lightest wash of black gouache.

5. Paint the foundation petals of your flower with a light hand. You may lightly sketch the flower first for guidance. Let the paint dry. (See A.)

6. Paint a second wash with the medium tone of gouache on the existing flower. Find the medium tones in your reference so the wash is placed selectively. (See B.)

7. To finish your piece, paint a few dark areas and leave small parts of the underlayers of the flower peeking through; this will give the flower form. (See C.)

8. Let your artwork dry before doing any pen work.

9. With your gel pens, pencil, and gouache, create details. Make marks as you like; I follow the flower petal for definition. Use the white gel pen for highlights, the pencil for medium tones, and the black gel pen for darker areas. The pencil is most versatile in this exercise because it can shade or make lines. (See D.)

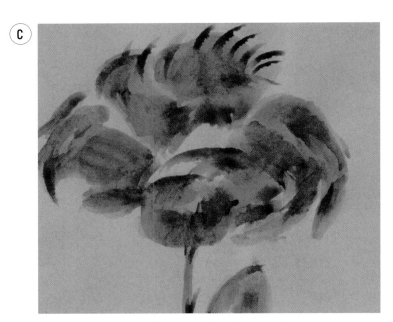

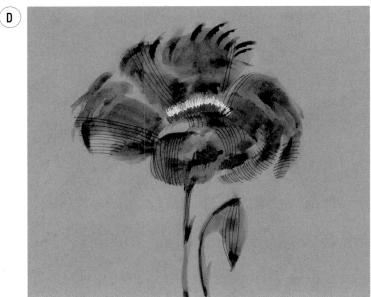

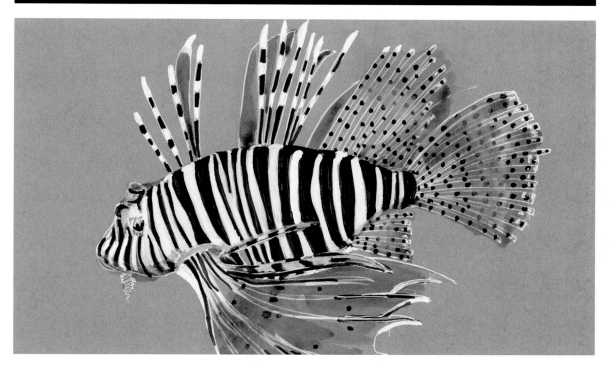

THE SECRET OF ACRYLIC INK

IN THIS EXERCISE, YOU WILL PLAY WITH ACRYLIC INK, WHICH IS TRANSLUCENT AND VERY DIFFERENT FROM GOUACHE. ACRYLIC INK MAKES A NICE ADDITION TO YOUR ART SUPPLIES IF YOU LIKE TO MIX MEDIA IN YOUR WORK. IT IS WATER RESISTANT, DRIES QUICKLY, AND FLOWS SMOOTHLY. IT ALSO WORKS WELL FOR WATERCOLOR EFFECTS AND FOR STAMPING. ITS FLUID NATURE FEELS WONDERFUL AS YOU MOVE THE INK ACROSS YOUR PAPER.

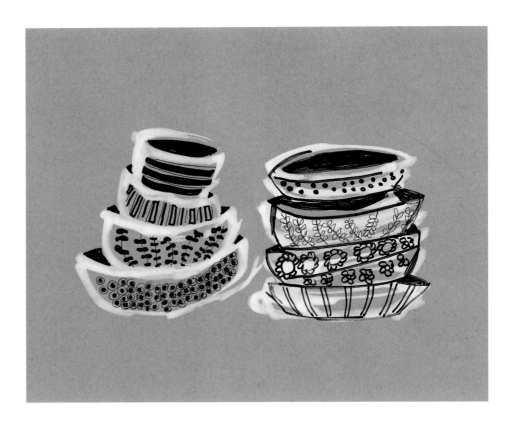

MATERIALS

Newspaper or large craft paper

Gray heavy cardstock

Palette with a convex well

Round brush

Black and white acrylic inks

Black or white gel pen

Gouache (optional)

1. Cover your work space with newspaper or large craft paper.

2. For your reference, go back to the kitchen. Grab a few bowls and stack them one inside the other to set up your still life.

3. Set up the gray paper you will paint on. Put a few drops of ink in your palette. Load the round brush with white ink and paint your bowl shapes. Paint a few washes for highlight and form. Let the paint dry.

4. Use the black ink to paint in detail. Because of the ink's water-resistant quality, you can put detail in a different medium if you wish. Let your artwork dry before doing any pen work, if you care to add another layer of detail.

5. The beauty of this versatile medium is that you can lay down a deliberate line and play with wash in gouache, ink, or watercolor, never smudging or smearing the line. You can work in reverse as well. You can put down a wash first, and then do line work as an overlay without smearing or smudging the wash.

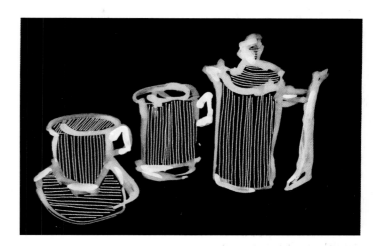

Exercise 21:

SUMI BRUSH WRITING

IN THIS EXERCISE, YOU WILL DISCOVER THE BEAUTY OF YOUR OWN HANDWRITING USING A SUMI BRUSH. THIS IS A GREAT WAY TO ADD WORDS TO PIECES YOU CREATE OR MAKE WORD ART THAT STANDS ALONE. EXPRESS YOURSELF IN YOUR LINES, STROKES, AND CURVING MARKS—THIS IS YOUR EXPRESSIVE FLOW. THE RHYTHM OF YOUR HAND AS YOU WORK AND THE LETTERS YOU MAKE IN PRINT OR CURSIVE IS CALLED "YOUR HANDWRITING," "YOUR HAND," OR "YOUR STYLE."

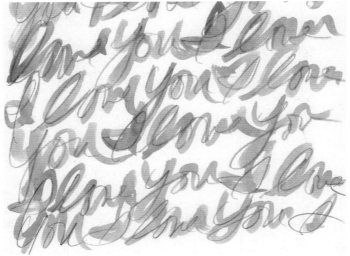

MATERIALS

Newspaper or large craft paper

Black gouache or acrylic ink

Palette

Inexpensive brush for mixing

Sumi brush (I use a 2, 4, or 6.)

30 or more sheets copy paper

A favorite quotation or word

Watercolor paper for final work

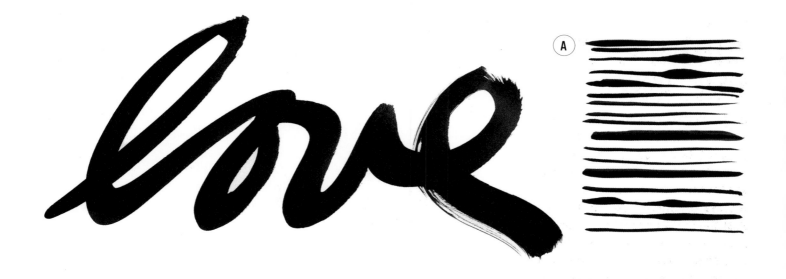

1. Cover your work space with newspaper or large craft paper.

2. Put a few generous dots of gouache onto your palette and slowly add water. Mix the gouache to a creamy, yogurt-like consistency. Use an inexpensive brush to mix the paint.

3. Load the Sumi brush with paint. Use the edge of your palette and twirl the brush to get excess paint off the brush and regain the point.

4. Hold the brush like a pencil or perfectly perpendicular to your writing sheet. Find what is comfortable for you. Stand and put your whole body into the work.

5. Your first exercise is line work. Make fine, medium, and thick lines with the tip of the brush. Pull the brush left to right across the page and make linear rows from the top to the bottom of the paper. You will get a sense of how long your loaded brush paints until you have to reload. Make five pages. (See A.)

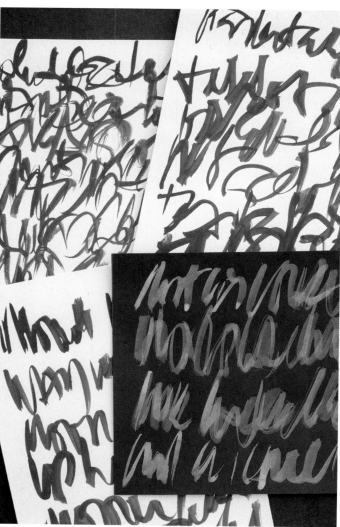

6. Your second exercise is making thick and thin lines within one row. Load your brush with paint. Pull and push your brush across the page without lifting it off the paper. Repeat the push-pull rhythm at least three to five times in one line. Go left to right across the page and make rows from the top to the bottom of the page. Make five pages. (See B.)

7. Your third exercise is making loops over and under with circular motions. Painting motions in this exercise emulate cursive writing. Load your brush with paint. Fill your page with loops. Move your brush clockwise for a few strokes and counterclockwise for a few strokes. Make five pages. This exercise is similar to an approach called Asemic writing, which fuses the look of cursive writing with abstract art—the words themselves don't have meaning, only the art behind it does. You can make "pretend" writing for fun as well. (See C.)

8. Now you are ready to jump into a word or alphabet exercise. Practice writing words or the alphabet in cursive or print. If certain letters speak to you, draw those for fun; my favorite letters are a and e.

9. Start with your name. Try the alphabet in uppercase and lowercase, and then mix it up.

10. Dance with the rhythm of your brush as it glides on the page. Play with scale and make some letters larger or smaller than others for interest. Remember to hold the brush like a pencil or perfectly perpendicular to your writing sheet. Find what is comfortable as you connect the letters. Pay attention to how many letters you can put on paper before reloading your paintbrush, which will come in handy when you make your final art. By the end of these exercises, you will see your personality "type."

11. For your final art piece, paint your favorite quotation on watercolor paper.

12. To clean up, rinse your brush with warm water, pull the bristles to make the tip, and lay it horizontally to dry.

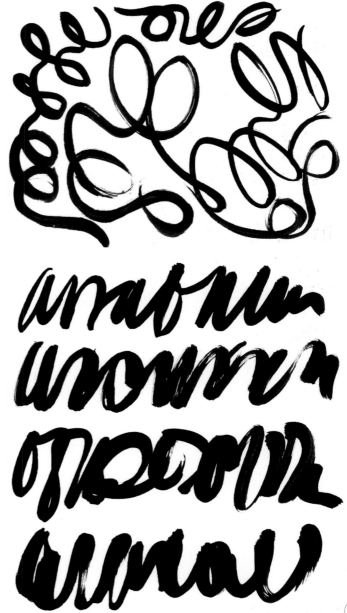

TORN PAPER STRIPS

EXPLORE DESIGN WITHOUT RULES USING TORN PAPER. THIS TACTILE AND PLAYFUL EXERCISE HAS LIMITLESS DESIGN APPLICATIONS AND POSSIBILITIES. TORN STRIPS OF PAPER FILL A PAGE WITH ROUGH AND JAGGED EDGES, GIVING A PAINTERLY, ABSTRACT EFFECT.

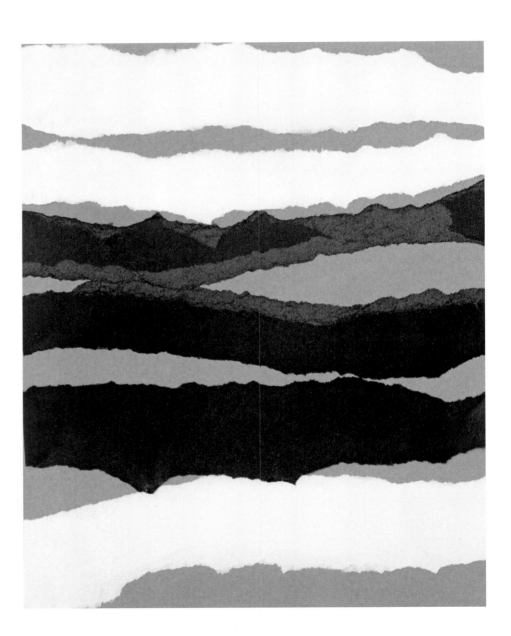

MATERIALS

Newspaper or large craft paper

Black and white lightweight paper or cardstock for tearing, 10" x 8" (25.4 x 20.3 cm)

Gray heavy cardstock for background, 10" x 8" (25.4 x 20.3 cm)

Inexpensive flat brush for applying decoupage or gel medium

Decoupage or gel medium

1. Cover your work space with newspaper or large craft paper.

2. Tear strips along the 10" (25.4 cm) side of the black and white papers. The strips will be 8" (20.3 cm) long.

3. Place the strips on the contrasting gray cardstock in the design of your choice. Place as many as you can fit. Fill the space from top to bottom and allow the contrasting gray color to show. This makes a painterly wave.

4. Brush the decoupage medium onto the back of your strips and glue down your design.

5. Weight under a heavy book until dry.

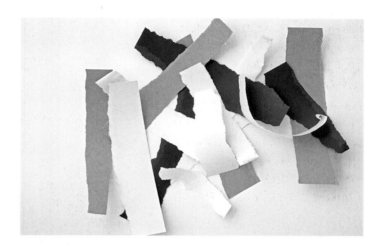

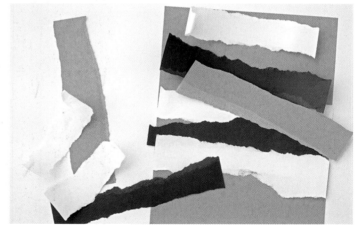

Exercise 23:

CIRCLES IN TORN PAPER

CONTINUE TO EXPLORE SIMPLE DESIGN
WITHOUT RULES USING TORN PAPER IN
CIRCULAR SHAPES. TEARING PAPER CREATES
ORGANIC AND PAINTERLY FORMS FOR MAKING
YOUR OWN MODERN ART MOSAIC.

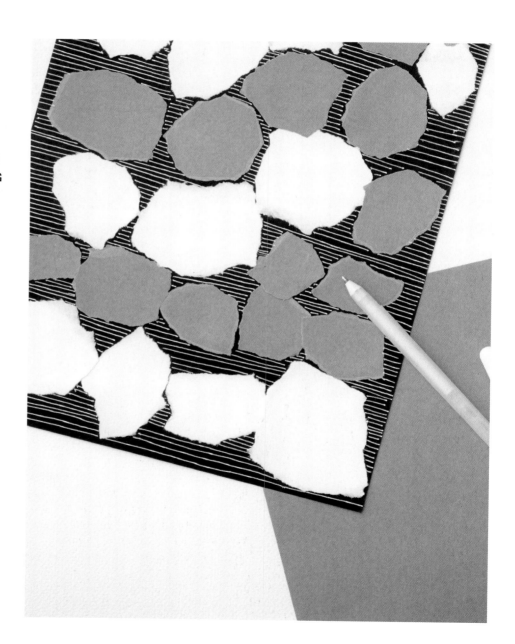

MATERIALS

Newspaper or large craft paper

Gray and white lightweight paper or cardstock for tearing

Black heavy cardstock for background

Inexpensive flat brush for applying decoupage or gel medium

Decoupage or gel medium

White gel pen

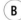

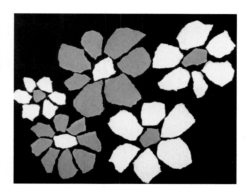

1. Cover your work space with newspaper or large craft paper.

2. Tear circles out of the gray and white papers. Vary the sizes for interest. (See A.)

3. Place the circles on the contrasting black cardstock in the design of your choice. (See B.)

4. Brush the decoupage medium onto the back of the circles and glue down your design.

5. Weight under a heavy book until dry.

6. For added interest, draw directional lines within the negative spaces using the white gel pen (opposite).

CUT, FOLD, AND GLUE

IN THIS EXERCISE, YOU'LL EXPLORE MORE DESIGN CONCEPTS WITH CUT AND FOLDED PAPER. THIS EXERCISE HAS EASY, FUN, AND INNER CHILD WRITTEN ALL OVER IT!

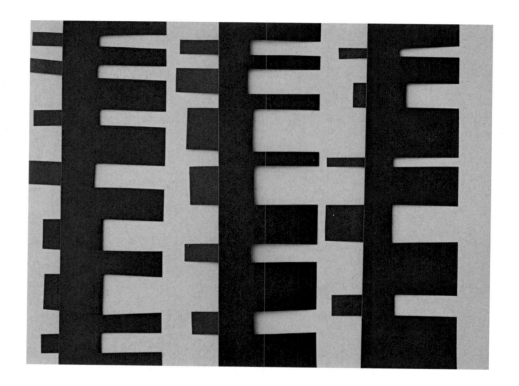

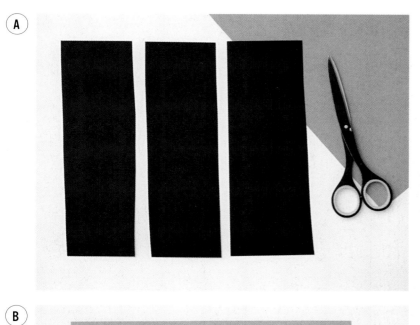

A

1. Cover your work space with newspaper or large craft paper.

2. With scissors or a craft knife and ruler, cut three strips from the black paper measuring approximately 2¼" x 8" (5.7 x 20.3 cm). (See A.)

3. Make 12 to 14 cuts into the strip starting ¾" (2 cm) from the edge. Space them apart as desired.

4. Fold over every other cut piece. The first fold is at your ¾" (2 cm) mark. The excess of the folded pieces overlaps the straight edge of the strip. (See B.)

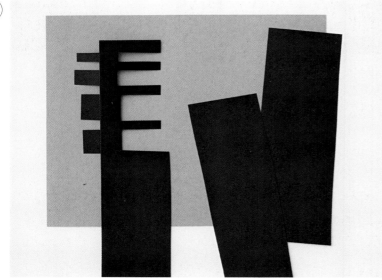

B

MATERIALS

Newspaper or large craft paper

Scissors

Craft knife

Ruler

Black heavy cardstock, 8½" x 11" (21.6 x 28 cm)

White or gray lightweight or heavy cardstock or Bristol, 8½" x 11" (21.6 x 28 cm)

Inexpensive flat brush for applying decoupage or gel medium

Decoupage or gel medium

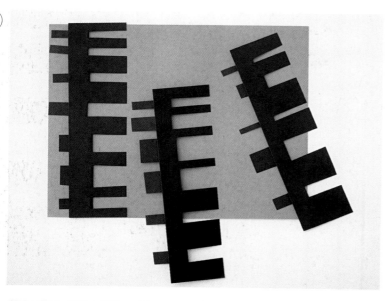

C

5. Turn the large strip over so the folded work does not show. (See C.)

6. Place the white or gray sheet of paper on your work space.

7. Brush the decoupage medium onto the back of your first strip and place on the left side of your background paper. Leave room for the placement of the additional strips. This is your starting point. The next two strips will be placed next to this one. Continue to cut and fold the other two strips as you did in steps 3 and 4. Place accordingly. (See D.)

8. Weight under a heavy book until dry.

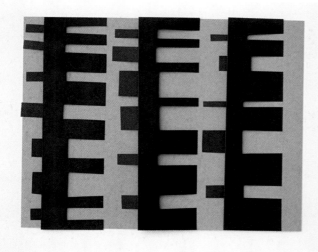

D

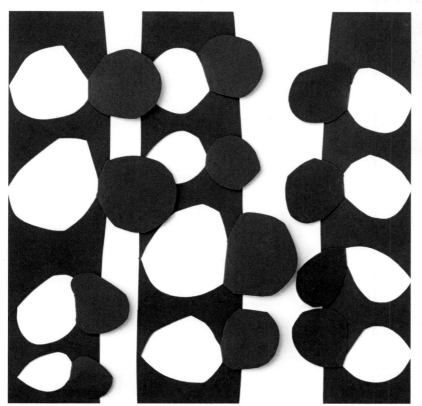

Circles cut into the
strips of paper

Strips cut in an oval
shape

MATERIALS

Newspaper or large craft paper

Scissors

White craft paper, heavy cardstock, or Bristol

Craft knife

Black craft paper or heavy cardstock

Inexpensive flat brush for applying decoupage or gel medium

Decoupage or gel medium

Straightedge

Exercise 25:

PAINTING WITH SCISSORS

IN THIS EXERCISE, WE EXPLORE LIVELY COMPOSITIONS WITH CUT PAPER SHAPES SUCH AS CIRCLES, TRIANGLES, HALF-MOONS, AND MORE. ALTHOUGH THE SHAPES ARE SO SIMPLE, THEY HAVE GRAPHIC POWER WHEN USED IN MULTIPLES. KEEP A FEW SMALL BOXES WITH CUT SHAPES TO PLAY WITH IF YOU NEED INSPIRATION.

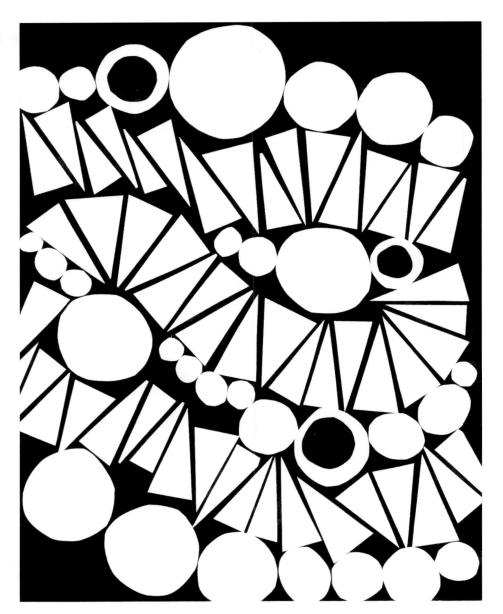

1. Cover your work space with newspaper or large craft paper.

2. With scissors, cut 26 circles from the white paper.

3. Take three to six of the solid white circles and cut a circle inside the circle. This new shape will be interspersed with your solid circles.

4. Cut 50 triangles from the white paper.

5. Place the black sheet of paper on your work surface.

6. Brush the decoupage medium onto the back of a circle shape and place it on the top left edge of your black paper. This is your starting point. Pick another circle, apply medium, and place next to the first circle, slightly touching. Continue to glue and place until you create a line of circles ending on the right edge of your paper. Your row can bend, curve, and move across the page in any type of flow.

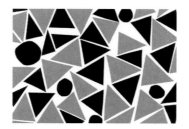

7. Brush medium onto the back of a triangle shape and place at the left edge of your black paper. Continue gluing and placing the triangle shapes across the page to the right edge of the paper. Follow the organic line created by your first row of circles. The triangles should be close but not touching, creating lines of negative space and a rhythm to the piece.

8. With the first two rows of your design complete, continue gluing and placing from left to right to fill your space using your cut shapes.

9. If any shapes extend over the edge, trim them flush with the paper using a straightedge and a craft knife.

10. Weight under a heavy book until dry.

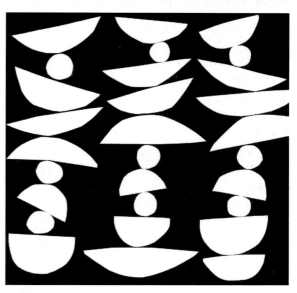

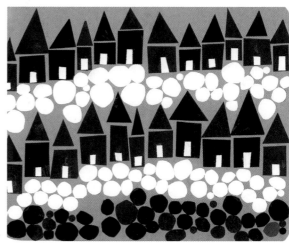

MATERIALS

Newspaper or large craft paper

Scissors or craft knife

Black craft paper or heavy cardstock

Inexpensive flat brush for applying decoupage or gel medium

Decoupage or gel medium

Gray craft paper or heavy cardstock

White gel pen

Exercise 26:

CUT PAPER FUN

THIS COMPOSITION CREATES BEAUTIFUL DIAMOND STARS. WE START WITH CUT PAPER TO CREATE OUR PRIMARY SHAPE AND THEN ADD DECORATIVE DETAIL WITH MARKS AND LINE WORK.

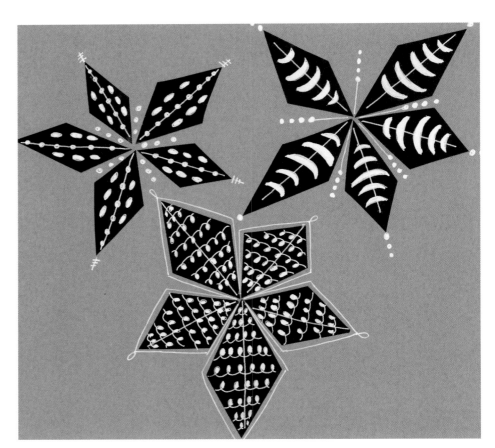

VARIATION

Add circle shapes to take the design even further!

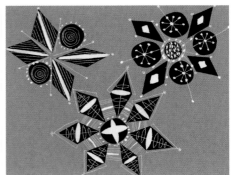

1. Cover your work space with newspaper or large craft paper.

2. With scissors or a craft knife, cut several diamond shapes out of black paper, five for each "star" you want to make. (See A.)

3. Brush the decoupage medium onto the back of the black diamond shapes and arrange in a star design on the gray paper. Draw a design on each diamond shape with the white gel pen by filling the space with fun marks. (You may choose to draw the designs on the diamond shapes while they are loose on your work space, and then adhere them afterward.) (See B and C.)

4. When the diamond shapes are finished, you can add designs on the gray base paper. Find fun negative space between the diamonds to fill with lines, dots, squiggles, ovals, and other marks. Outline the diamond shapes for more punch in your design. The tips of the diamonds can be extended with simple touches to add elegance. (See D.)

5. Weight under a heavy book until dry.

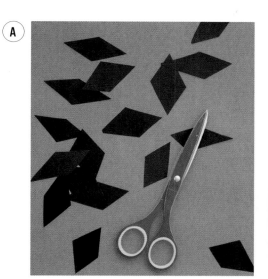

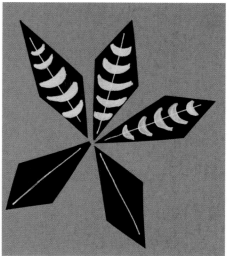

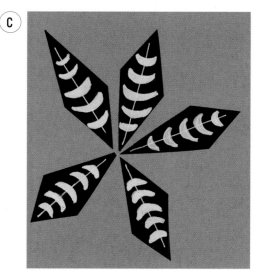

HOLE PUNCH GARDEN

USING OTHER TOOLS TO CREATE ART KEEPS YOUR IMAGINATION OPEN AND FREE WITH FUN POSSIBILITIES. HERE, YOU'LL EXPLORE WITH CUT SHAPES AND HOLE-PUNCHED PAPER TO CREATE A VARIETY OF UNIQUE LEAVES AND FLOWERS.

VARIATION

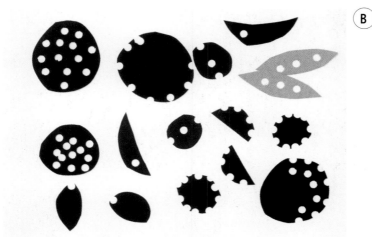

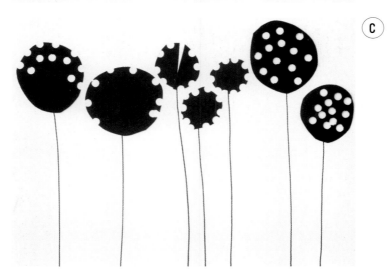

MATERIALS

Newspaper or large craft paper

Scissors or craft knife

Black and gray lightweight or heavy cardstock

Hole punch

White craft paper, heavy cardstock, or Bristol

Inexpensive flat brush for applying decoupage or gel medium

Decoupage or gel medium

Permanent marker

1. Cover your work space with newspaper or large craft paper.

2. With scissors or a craft knife, cut seven circles of varying sizes out of the black paper. (See A.)

3. Cut eight to twelve leaf shapes out of the black and gray papers.

4. Create decorative detail by hole punching your cut shapes. Hole punch the edges and the centers as well. (See B.)

5. Place a white sheet of paper on your work surface.

6. Place the shapes to make a floral story on this white background.

7. Brush decoupage medium onto the backs of your shapes, and glue down your design.

8. Draw stems with marker to complete your flowers. (See C.)

9. Weight under a heavy book until dry.

Exercise 28:

HOLE PUNCH VILLAGE

THIS EXERCISE OF ARCHITECTURAL
EXPLORATION USES CUT AND HOLE-
PUNCHED PAPER TO CREATE A VILLAGE. CUT
RECTANGLES, TRIANGLES, AND SQUARES
ALLOW YOU TO CREATE A VARIETY OF
BUILDINGS. A HOLE PUNCH IS USED FOR
DECORATIVE TREATMENTS.

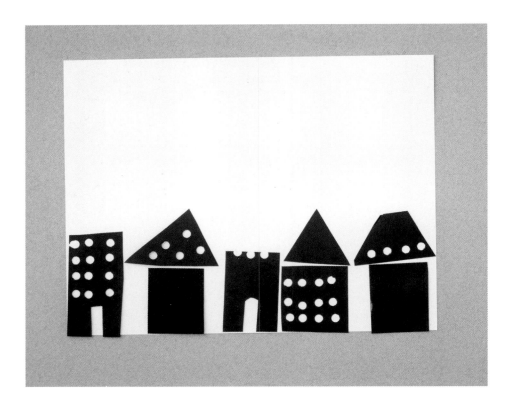

MATERIALS

Newspaper or large craft paper

White craft paper, heavy cardstock, or Bristol

Scissors

Black craft paper or heavy cardstock

Hole punch

Craft knife

Inexpensive flat brush for applying decoupage or gel medium

Decoupage or gel medium

A

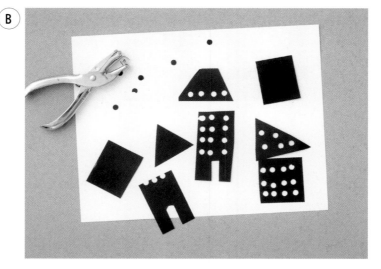

B

1. Cover your work space with newspaper or large craft paper.

2. Place a white sheet of paper on your work surface.

3. With scissors, cut five rectangles of varying sizes out of the black paper.

4. Cut three roof shapes out of the black paper. (See A.)

5. Create decorative detail by hole punching your cut shapes. Hole punch the edges and the centers as well. Cut doorways with a craft knife. (See B.)

6. Place the shapes on the white background to make a village story.

7. Brush decoupage medium onto the backs of your shapes, and glue down your design.

8. Weight under a heavy book until dry.

SKETCHING WITH A CRAFT KNIFE

IN THIS EXERCISE, YOU WILL CREATE A SCENE WITH CUTOUT PAPER SHAPES. YOUR CRAFT KNIFE BECOMES YOUR DRAWING INSTRUMENT. YOU WILL CUT AWAY SHAPES TO FORM WINDOWS, TURRETS, ROOFTOPS, CHIMNEYS, AND EVEN ROADS.

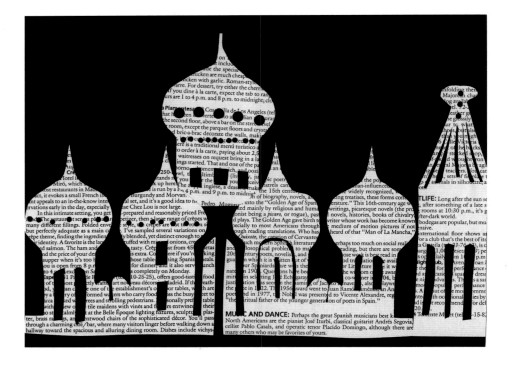

1. Cover your work space with newspaper or large craft paper.

2. Select your architectural reference material from a travel book, magazine, or online.

3. On your text or scrapbook paper, lightly sketch your buildings to serve as cut guides. Include the silhouette, some window detail, and a few architectural features.

4. Place the page on a cutting mat and cut out the silhouette with a craft knife and a straightedge.

5. Use your craft knife and a hole punch for cutting out detail work, such as windows and selected architectural features.

6. Place a black or white sheet of paper on your work surface. Arrange your cutouts on the paper.

7. Brush decoupage medium onto the back of your silhouette and glue down your design.

8. Weight under a heavy book until dry.

MATERIALS

Newspaper or large craft paper

A few pages from an old book with text on it or scrapbook paper with a design

Pencil

Cutting mat

Craft knife

Straightedge

Hole punch

Black or white craft paper or heavy cardstock

Inexpensive flat brush for applying decoupage or gel medium

Decoupage or gel medium

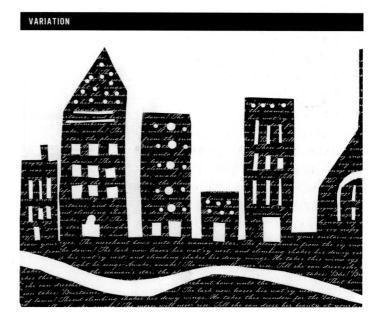

VARIATION

Exercise 30:

STENCIL ART

IN THIS EXERCISE, YOU WILL CUT HEAVY
CARDSTOCK TO MAKE A STENCIL TEMPLATE,
AND THEN PRINT YOUR DESIGN WITH A
STIPPLING TECHNIQUE.

YOU HAVE TWO CHOICES FOR MAKING A
STENCIL: WITH ACETATE OR WITH CARDSTOCK.
YOU CAN KEEP AND REUSE AN ACETATE
STENCIL, WHEREAS PAPER WILL HAVE A SHORT
DESIGN LIFESPAN. THE CARDSTOCK OPTION
IS AN INEXPENSIVE WAY TO TRY STENCILING
BEFORE INVESTING IN MORE EXPENSIVE
MATERIALS.

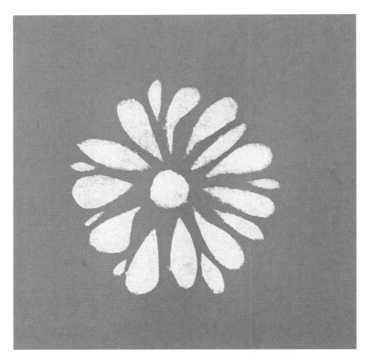

MORE STENCILED ARTWORK: A SIMPLE GEOMETRIC DESIGN AND A STEM DESIGN

MATERIALS

Newspaper or large
craft paper

Acetate, smooth
heavy cardstock,
or Bristol for
the stencil

Permanent marker

Pencil

Cutting mat

Straightedge

Craft knife

Artist tape

White, black, or
gray cardstock

Repositionable
adhesive spray

Plastic spoon

White and black
block-printing ink

Palette

Palette knife

Stenciling brush,
foam dauber, art
sponge, or flat
sponge brush

Scrap paper

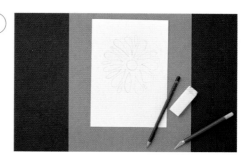

1. Cover your work space with newspaper or large craft paper.

2. Draw a simple flower design onto the acetate with a permanent marker or with pencil on the cardstock. (See A.)

3. Place a cutting mat on your work surface, and use a straightedge and craft knife to cut out the stencil. Remember, the areas you cut out will be the areas that print. (See B.)

4. Tape down your cardstock, then secure the stencil template on top to avoid movement. Use removable artist tape or spray the back of the stencil with repositionable adhesive. Keep your cut edges flush on the paper. (See C.)

5. Place a spoonful of ink on your palette. Warm up the ink with a few flips of a palette knife.

6. Load ink onto the stenciling brush, art sponge, or foam dauber. Tap the coated brush on scrap paper to remove any excess ink.

7. Hold the brush perpendicular to your paper as you tap the paint in an up-and-down motion to cover the cutout areas of the stencil. This is called stippling. Apply a thin, even coat. Do not use strokes, because your edges will clog and run underneath your template. Let dry. (See D.)

8. Repeat until the coverage is evenly distributed.

9. Make sure the ink is dry before peeling up the template to reveal your design. (See E.)

10. If you are attempting a layered piece of work with additional colors, let the first layer dry completely before adding another layer of color to your art.

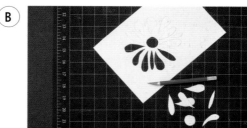

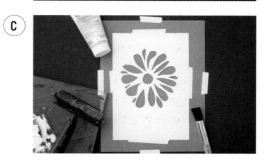

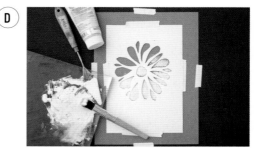

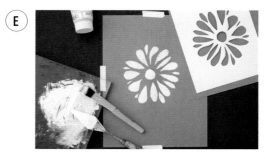

Exercise 31:

FOUND OBJECT PRINTING

IN THIS EXERCISE, YOU WILL MAKE PRINTED
ART USING A LEAF, OR YOU CAN PRINT WITH
ANOTHER FOUND OBJECT IF YOU PREFER. FIND
REFERENCES IN NATURE OR AROUND THE
HOUSE. HOW ABOUT THAT JUNK DRAWER WHERE
EVERYTHING ENDS UP? TRY BUBBLE WRAP, A
CLEAN NEW SPONGE, OR A PAPER TOWEL WITH
DIVOTS PRESSED INTO THE PAPER. REMEMBER
TO ALWAYS RUN A TEST PRINT ON SCRAP
PAPER BEFORE MAKING A FINAL PRINT.

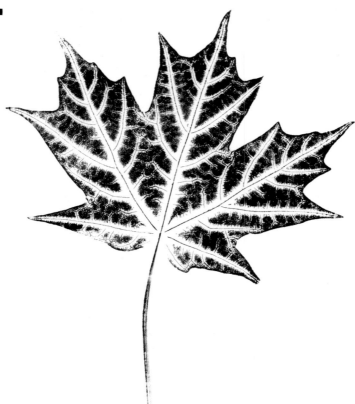

MATERIALS

Newspaper or large
craft paper

Paint or ink pad
(color depends on
paper color)

Palette

Round sponge brush
with flat bottom

Fresh leaf (needs to
be flexible)

White, tan, black,
or gray smooth
lightweight or
heavy cardstock

Scrap paper

Brayer

1. Cover your work space with newspaper or large craft paper.

2. Place paint on a palette or use an ink pad. Load the sponge brush with paint by dabbing.

3. Lay the leaf on your newspaper wrong side up, as the veins from the underside of the leaf make for a better print.

4. Apply the paint to the leaf in a dabbing motion. Dab all around the leaf for full coverage, applying a few thin layers at a time. If using an ink pad, press the ink all over the leaf for full coverage.

5. Place the inked leaf paint side down on your paper. Cover the leaf with scrap paper or newspaper.

6. Roll your brayer over the scrap paper, moving smoothly over the entire leaf. You will sense where it is under the scrap paper. Do not roll too much or you will smudge the ink underneath.

7. Remove the scrap paper and lift the leaf carefully to reveal your print.

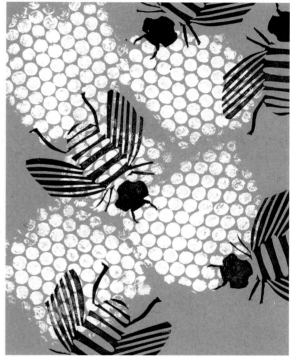

Printed bubble wrap is used for the background in this block-printed piece.

Exercise 32:

STAMP CARVING TUTORIAL

IN THIS EXERCISE, YOU WILL CREATE SIMPLE STEMMED FLORA CUT FROM RUBBER BLOCKS. YOU'LL LEARN HOW TO CARVE YOUR OWN STAMP AND TRULY UNDERSTAND POSITIVE AND NEGATIVE SPACE. YOUR STAMPS CAN BE USED OVER AND OVER AGAIN TO CREATE A VARIETY OF WORKS.

MATERIALS

Newspaper or large craft paper

Soft lead pencil

Tracing paper or copy paper

Carbon paper (optional)

Bone folder or wooden spoon (optional)

Rubber carving block or linoleum block (linoleum blocks provide more detail)

Permanent marker

Cutting mat

Linoleum cutting tool with tips 1 through 5

Craft knife (optional)

Plexiglass (optional)

Art brush

White, black, gray, or tan lightweight or heavy cardstock

Artist tape

Scrap paper

Plastic spoon

Block printing ink

Palette

Palette knife

Brayer

Ink pad (optional, for less cleanup)

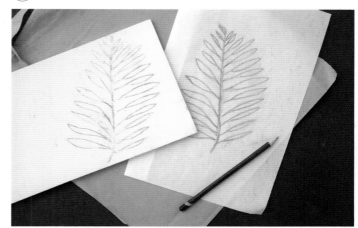

1. Cover your work space with newspaper or large craft paper.

2. Set up two work areas: one with a cutting mat to cut the block and one for inking and printing.

3. Find a reference from nature or in a book, such as a leaf.

4. Using a soft lead pencil, draw your leaf design onto tracing paper or copy paper. (See A.)

5. Transfer the design onto your carving block. Here are the options:

OPTION 1: Place the carbon paper between the tracing paper drawing and the block. Trace over your drawing with a pencil to transfer the design onto the block.

OPTION 2: Place your tracing paper, sketch side down, onto the rubber block. Using a bone folder or a wooden spoon, rub the back of the paper to transfer the design onto the block.

OPTION 3: If you used copy paper, flip your drawing over and with a soft lead pencil, cover the wrong side of your sketch with shading. Hold the drawing wrong side up to a window and use it as a lightbox. Smooth the graphite lightly with a tissue. Place the paper, drawing side up, on the block and trace over your drawing with a pencil to transfer the design onto the block.

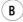

B

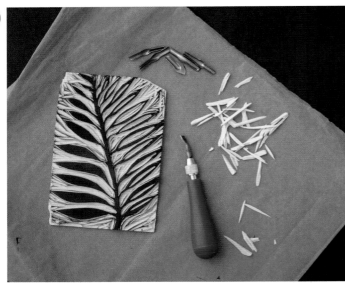

C

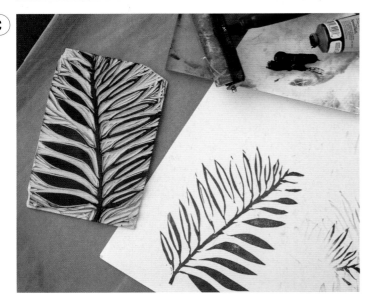

6. Draw over your transferred design with a permanent marker, because bits of the pencil drawing may disappear with handling.

7. Place the block on top of your cutting mat and cut into the design with the cutting tools. Always cut away from your body. Keep your fingers behind your cutting instrument, not in front.

8. Remember that what you cut away will be the negative space, and the raised part of block will print the design, so the image will appear in reverse when printed. There is no right or wrong way, but if you carve words, you need to work in reverse. I learned this the hard way!

9. Use the V-shaped tip for detail and use the U-shaped tip for carving away large areas. (See B.)

10. Keep the large rectangular or square block shape, as it is easier to handle for printing. Be sure to cut away excess rubber around the design so it is raised and only the shape touches paper when printing.

11. An alternative approach is to completely cut around the design with a craft knife, leaving the shape free to handle. It can then be adhered to a piece of plexiglass for easier handling. Commercial stamps have a wooden or plexiglass backing for this purpose.

12. Brush away excess cuttings on the stamp using a clean, dry art brush, or rinse it with mild soap and warm water, then pat dry with a lint-free towel and air-dry. If rinsing, the block needs to be completely dry before printing.

13. Secure the paper to your work space with tape. Gather scrap paper to test your stamp.

14. Place a spoonful or two of block printing ink on a palette. Warm up your ink by flipping it over with the palette knife.

15. Load the brayer completely and evenly with ink. Roll up, down, and crisscross, and then up and down again. (I do this a few times.) When you hear tackiness in the ink, it is ready to apply to the cut block.

16. Place the cut block on your newspaper, design side up, and roll the brayer over your stamp design. Roll on a few *thin* layers of paint. Cover the block evenly.

17. Test prints on the scrap paper to see if there are any stray marks from spots not cut away or not cut deep enough. If needed, make adjustments to your stamp and test again. (See C.)

18. Place the design on your art paper. For small stamps, apply pressure with your palm. For larger stamps, I use a piece of plexiglass to apply even pressure. You can also use a book, if needed.

19. Reapply ink to the block as you continue to print your design to fill a page. (See D.)

20. If you choose to use an ink pad instead, press the ink pad, ink side down, all around the block for full coverage. With small blocks you can hold the block, design side down, and press into the ink pad. Continue to ink up your stamp and stamp your design on your paper. Re-ink between applications.

21. Experiment with the pressure you apply to the stamp. If you vary the pressure, you can make the design appear rustic and worn. With solid, even pressure the look is more graphic and clean.

22. To clean up, rinse the block in warm water and mild soap. Pat dry with a lint-free towel and let air-dry.

What you carve away becomes the negative space.

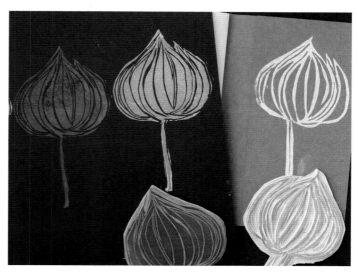

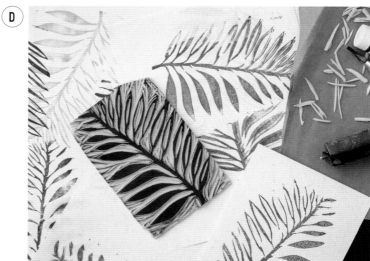

D

NOTE: Bristol paper will give a clear and clean print, and watercolor paper will give a more rustic, unfinished, textured print. Watercolor paper has valleys, and the paint doesn't touch the paper in those areas. The finished look is up to you.

Exercise 33:

BLOCK PRINT PATTERNS

IN THIS EXERCISE, YOU WILL MAKE A SIMPLE PATTERN BY BLOCK PRINTING WITH A CARVED STAMP. THIS TECHNIQUE IS PERFECT FOR MAKING GREETING CARDS OR A LOVELY DESIGN ON A TEA TOWEL. (WHEN WORKING WITH FABRIC, BE SURE TO USE TEXTILE INKS.)

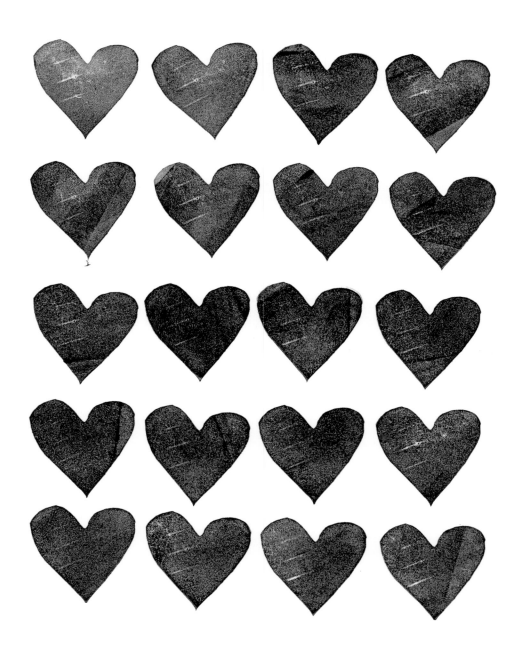

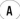

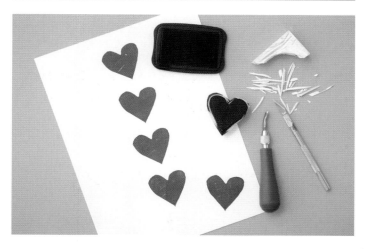

MATERIALS

Newspaper or
large craft paper

Pencil

Permanent marker

Rubber carving
block

Cutting mat

Linoleum cutting
tools and tips

Art brush

Artist tape

White, gray,
or tan smooth
lightweight or heavy
cardstock, Bristol,
or watercolor paper
(see note)

Scrap paper

Ink pad

1. Cover your work space with newspaper or large craft paper.

2. Set up two work areas: one with a cutting mat to cut the block and one for inking and printing.

3. With pencil or permanent marker, draw a simple heart shape directly onto your rubber block. (See A.)

4. Place the block on top of your cutting mat and cut into the design with the cutting tools. Always cut away from your body. Keep your fingers behind your cutting instrument, not in front.

5. Remember that what you cut away will be the negative space, and the part of the block that is raised will be the printed design, so the image will appear in reverse.

6. Use the V-shaped tip for detail and use the U-shaped tip for carving away large areas. Save larger pieces that are cut away to carve additional stamps. More art supplies! Be sure to cut away excess rubber around the design so it is raised and only the shape touches the paper when printing.

7. Brush away excess cuttings on the stamp using a clean, dry art brush, or rinse it with mild soap and warm water, then pat dry with a lint-free towel and air-dry. Use either method to clear away any residue from cutting. If rinsing, the block needs to be completely dry before printing.

8. Secure the art paper to your work space with tape. Have scrap paper handy for test prints.

9. Press the ink pad, ink side down, all around the cut block for full coverage. Or with small blocks such as these, you can hold the block, design side down, and press into the ink pad.

10. Test prints on the scrap paper to see if there are any stray marks from spots not cut away or not cut deep enough. If needed, make adjustments to your stamp and test again.

11. Place the stamp on your art paper and apply even pressure with your palm. Experiment with the pressure you apply to the stamp. If you vary the pressure, you can make the design appear rustic and worn. With solid, even pressure the look is more graphic and clean.

12. For a block repeat in its simplest form, stack the heart motif in a basic grid left to right, lining up your designs in rows, as shown on page 94. Re-ink after each impression.

13. To clean up, rinse the block in warm water and mild soap. Pat dry with a lint-free towel and let air-dry.

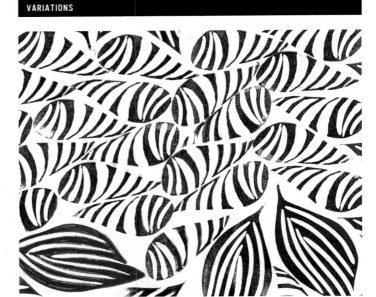

This design uses two different stamps.

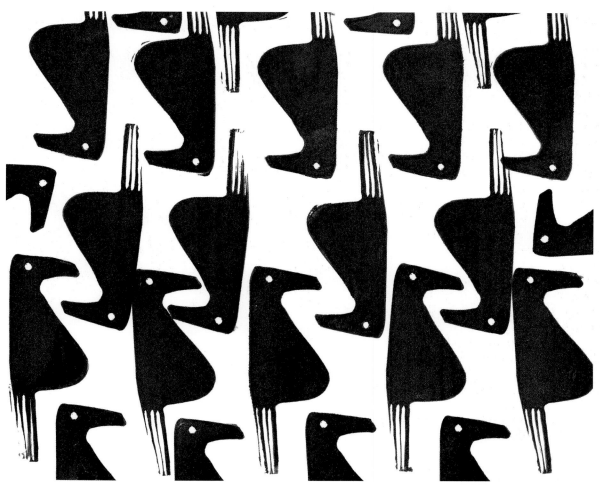

NOTE: Rubber blocks come in various widths and sizes. I prefer thicker blocks, as the larger, thinner variety tends to split with use. The thicker blocks are easier to handle when printing, too.

This design is stamped in two directions to add interest to the pattern.

Exercise 34:

BLOCK-PRINTED SCENES AND CITYSCAPES

IN THIS EXERCISE, YOU WILL CREATE A CITY SCENE WITH SIMPLY CUT RUBBER BLOCKS IN THE SHAPES OF RECTANGLES, SQUARES, AND TRIANGLES. EVEN THE SIMPLEST CUTS MAKE WONDERFUL ROOFTOPS, WINDOWS, AND DOORS. BLACK AND WHITE INK COME ALIVE AGAINST A RUSTIC BACKGROUND OF CRAFT PAPER.

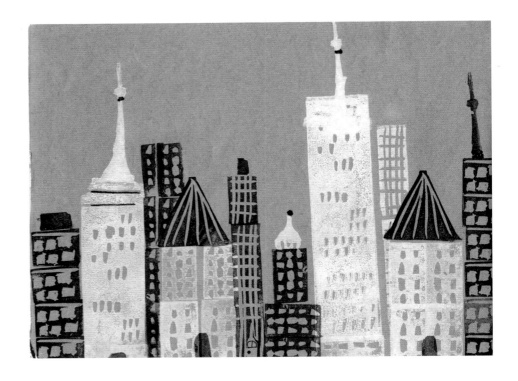

A

MATERIALS

Newspaper or large craft paper

Permanent marker

Rubber carving block

Cutting mat

Craft knife

Straightedge

Linoleum cutting tool and tips

Ballpoint pen

Art brush

Artist tape

White, black, or gray lightweight or heavy cardstock or brown craft paper

Scrap paper

Ink pad

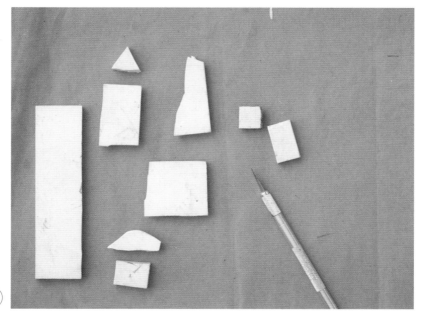

1. Cover your work space with newspaper or large craft paper.

2. Set up two work areas: one with a cutting mat to cut the block and one for inking and printing. (See A.)

3. With permanent marker, draw a few triangles, squares, and rectangles directly onto your rubber block.

4. Place the block on top of your cutting mat and cut out the shapes with a craft knife and straightedge, or cut free-form if you prefer. Always cut away from your body. Keep your fingers behind your cutting instrument, not in front. (See B.)

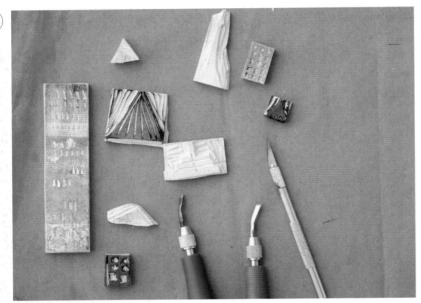

C

D

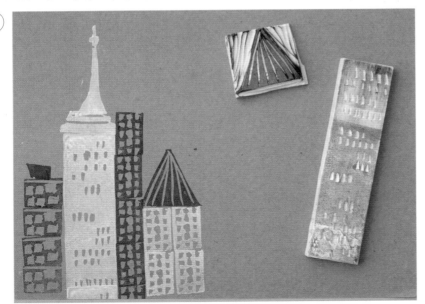

5. For detail, cut windows by making small nicks into the stamp with your cutting tools. You can also use a ballpoint pen to make divots in the rubber stamp. Remember that what you cut away will be the negative space, and the part of the block that is raised will be the printed design, so the image will appear in reverse when printed.

6. Use the V-shaped tip to make pattern details on the facades, and use the U-shaped tip for carving away large areas. Be sure to cut away excess rubber around the design so it is raised and only the shape touches the paper when printing.

7. Brush away excess cuttings on the stamp using a clean, dry art brush, or rinse it with mild soap and warm water, then pat dry with a lint-free towel and air-dry. Use either method to clear away any residue from cutting. If rinsing, the block needs to be completely dry before printing.

8. Secure the art paper to your work space using tape. Have scrap paper handy for test prints.

9. Press the ink pad, ink side down, all around the cut block for full coverage. Or with small blocks, you can hold the block, design side down, and press into the ink pad. (See C.)

10. Test prints on the scrap paper to see if there are any stray marks from spots not cut away or not cut deep enough. If needed, make adjustments to your stamp and test again.

11. Place the stamp on your art paper and apply even pressure with your palm. Stamp your city facades (rectangles and squares) first, moving from left to right. Re-ink after each impression.

12. Now stamp the rooftops with triangles. (See D.)

13. Experiment with the pressure you apply to the stamp. If you vary the pressure, you can make the design appear rustic and worn. With solid, even pressure the look is more graphic and clean.

14. To clean up, rinse the block in warm water and mild soap. Pat dry with a lint-free towel and let air-dry.

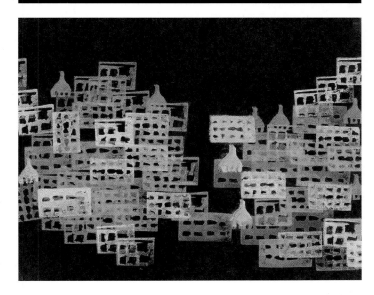

VARIATION

EMBELLISHED BLOCK-PRINTED SHAPES WITH LINE WORK AND PAINT

IN THIS EXERCISE, YOU WILL USE A BLOCK-PRINTED SHAPE AS YOUR BASE ARTWORK, AND THEN EMBELLISH IT WITH GOUACHE AND GEL PEN TO ADD STYLE AND DIMENSION. PICK A DESIGN YOU CARVED IN A PREVIOUS EXERCISE OR CREATE A NEW ONE. I AM USING A FAVORITE NAUTICAL MOTIF, THE WHALE.

VARIATION

MATERIALS

Newspaper or large craft paper

Artist tape

White, gray, or tan smooth lightweight or heavy cardstock, Bristol, or watercolor paper

Scrap paper

Carved stamp from previous exercise (or to create a new one, see page 90)

Ink pad, black or white depending on paper color

Palette

Black or white gouache

Inexpensive brush for mixing

Brushes (I used a round brush.)

Black or white paint pen, marker, or gel pen

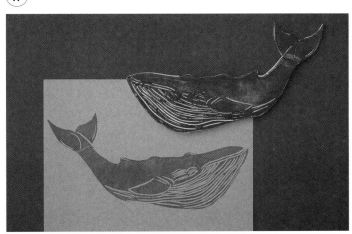

(A)

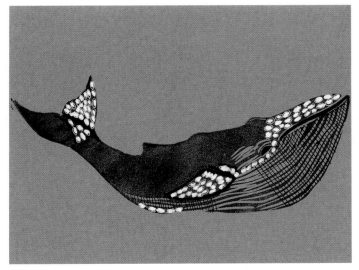

(B)

1. Cover your work space with newspaper or large craft paper.

2. Secure the art paper to your work space using tape. Have scrap paper handy for test prints.

3. After first testing your stamp to make sure the impression is how you intend it to be, place the stamp on your art paper and apply pressure with your palm for small stamps. For larger stamps, I use a piece of plexiglass to apply even pressure. You can also use a book, if needed. Stamp your design(s) using the ink pad, reapplying ink to the block if you choose to print your design to fill a page. Let it dry thoroughly. (See A.)

4. Study your work and find areas you wish to embellish with marks.

5. Mix the gouache on a palette and, along with the paint pens or other marking tools, paint and mark both the printed and the negative spaces. (See B.)

VARIATION

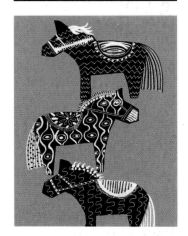

Exercise 36:
STITCHED BLOCK PRINTS

THIS EXERCISE INCORPORATES SIMPLE
STITCHING AS AN EMBELLISHMENT TO
BLOCK-PRINTED ART. YOU CAN ALSO
APPLY THIS TECHNIQUE TO PAINTED
OR DRAWN PIECES YOU HAVE MADE.
THE RESULT MAKES A GREAT GIFT OR
GREETING CARD.

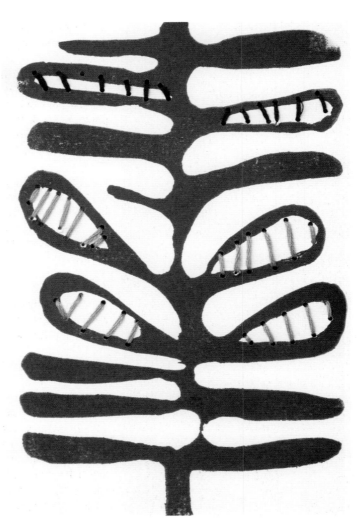

MATERIALS

Newspaper or large
craft paper

1 or 2 pieces heavy
cardstock, 5" x 7"
(12.7 x 17.8 cm)

Artist tape

Scrap paper

Carved stamp from
previous exercise
(or to create a new
one, see page 90)

Ink pad

Hole punch,
1/16" (2 mm) round

Embroidery needle

Embroidery floss

Scissors

Glue (optional)

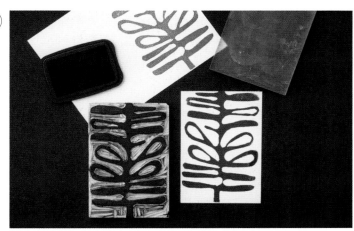

1. Cover your work space with newspaper or large craft paper.

2. Secure the cardstock to your work surface with tape. Have scrap paper handy for test prints. Always test out the stamp on a scrap piece of paper before printing onto your final paper.

3. Press the ink pad, ink side down, all around the cut block for full coverage. Or with small blocks, you can hold the block, design side down, and press into the ink pad.

4. Place the stamp on your art paper and apply even pressure with your palm. Re-ink after each impression. (See A.)

5. Allow the artwork to dry for at least 15 minutes.

6. Decide where your sewing embellishment will appear on your card. I chose the negative spaces within the leaves. Hole punch the card to allow for sewing. Space the holes far enough apart so no tearing occurs between holes. (See B.)

A WHIPSTITCH

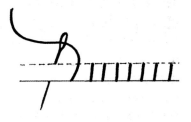

7. Thread your embroidery needle with floss and stitch your hole-punched card with a simple whipstitch. (See C.)

8. Make a knot to finish the stitch on the back of the card, trim the floss, and secure with a piece of tape. If desired, sew a simple running stitch around the edge to add a frame to your art.

9. You may cover the back by gluing on another 5" x 7" (12.7 x 17.8 cm) card.

GALLERY

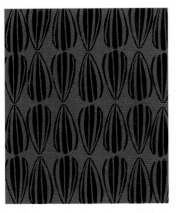

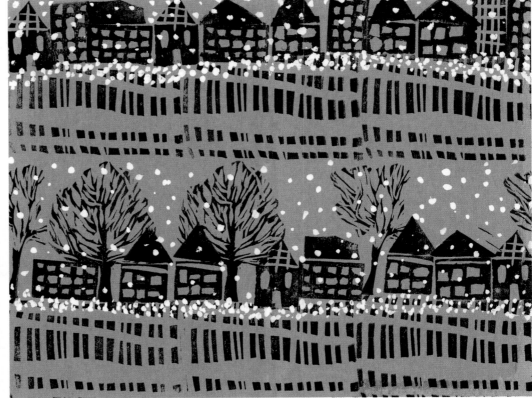

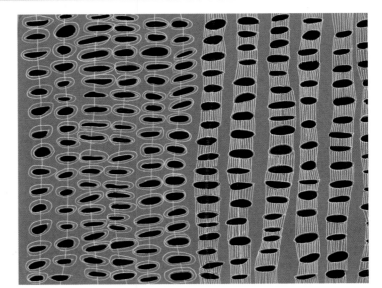

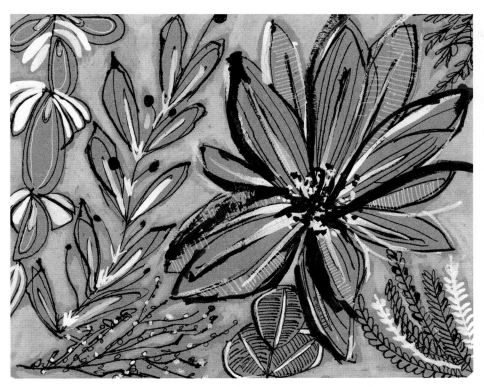

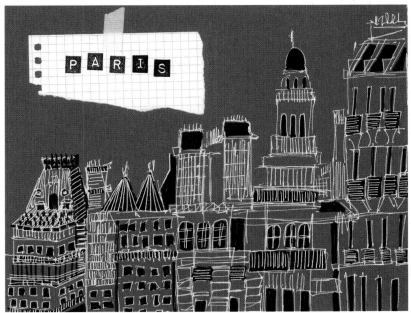

GALLERY

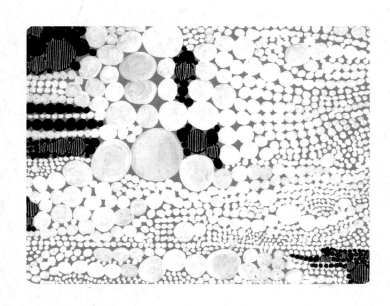